BEADED
BUGS

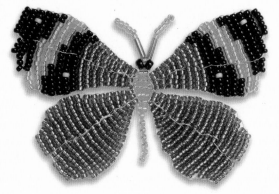

Nicola Tedman with Jean Power

Ivy Press

First published in the UK in 2012 by

Ivy Press

210 High Street
Lewes
East Sussex BN7 2NS
United Kingdom
www.ivypress.co.uk

British Library Cataloguing-in-Publication Data
A catalogue record for this book is available from
the British Library

ISBN:978-1-908005-26-7

This book was conceived, designed and produced by

Ivy Press

Creative Director *Peter Bridgewater*
Publisher *Sophie Collins*
Editorial Director *Tom Kitch*
Senior Designer *James Lawrence*
Designer *Clare Barber*
Photographer *Andrew Perris*
Illustrators *Peters & Zabransky*

Printed in China

Colour origination by Ivy Press Reprographics

10 9 8 7 6 5 4 3 2 1

IMPORTANT!

SAFETY WARNING: The beaded bugs are not
toys. They have small, removable parts that are
a choking hazard and should be kept out of the
reach of small children under the age of three.

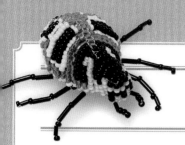

CONTENTS

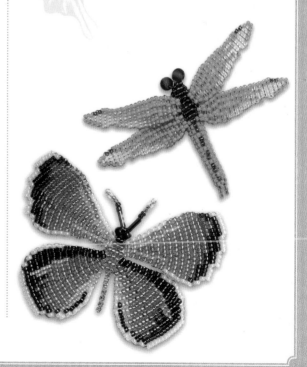

INTRODUCTION

THE NEAT SHAPES AND BRILLIANT COLORS OF INSECTS MAKE THEM IDEAL SUBJECTS FOR SMALL BEADING PROJECTS.

Gleaming wings, shiny jointed legs, and delicate angled antennae are all simple to render realistically with beads, sometimes with such lifelike results that you have to pick the creature up to accept that it's not going to fly away.

Many insect species have marvellously graphic markings, easily rendered in beads.

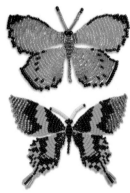

The basic butterfly pattern readily changes to a swallowtail with the addition of "tails" to the wings.

All the creatures in this book are based on seven basic patterns, then adapted to imitate real moth, beetle, and butterfly species from all over the world. They're not hard to replicate, even for a novice beader, although if you've never beaded before it's worth practicing a little before starting on your first project, simply because the scale is so small.

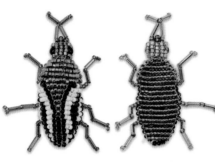

Legs and antennae are made with combinations of bugle and seed beads.

A few ground rules for great results:
• Buy good-quality beads (many recommend Japanese or Eastern European brands), and make sure that you're working with the size given in the pattern. Cheap beads may seem like a bargain but they often have irregularly sized holes, which can make repeated wire threading difficult.

• Invest in a craft light. They aren't expensive, and they have a flexible neck and a very strong magnifying lens, making them invaluable for fine work.

• If you're new to beading, start with one of the butterflies. They are simple and you can learn how to use the beading chart without being distracted by the three-dimensional elements.

The size of the projects means that they're quick to complete, and they make effective small accessories (pin a dragonfly to a coat lapel or a ladybug to a beret, for example) or even tiny desktop ornaments. So order your materials, turn the page, and get beading!

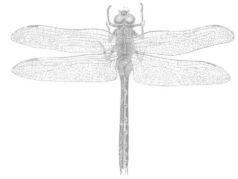

The airy quality of a dragonfly's wings can be echoed by using a mix of transparent and opaque iridescent beads.

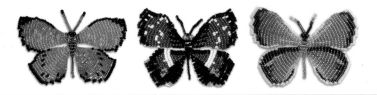

BASIC BEADING TECHNIQUES

Making wire beaded butterflies and bugs requires just a few basic techniques; once learned, they will help you to create all the winged and crawling creatures you desire. If you are new to wire beading, you may want to experiment first with some scrap wire and beads to help you get the hang of them before jumping in with your first project.

BEADING THE FIRST TWO ROWS

The first two rows are worked slightly differently from the others; they are both threaded on at once, with each row being read from the chart in a different direction.

1 Following the appropriate chart, pick up the beads for rows 1 and 2, reading row 1 from left to right and row 2 from right to left.

2 Center the beads on the wire and pass the right wire end through all the beads you picked up for row 2; the first bead you will thread through will be the one with the left wire coming out of it.

3 Pull the wires tight so that the beads for row 2 sit above the beads for row 1.

USING CHARTS

These charts are designed to be easy to follow, with each row starting at the left side regardless of whether or not the beads sit centrally above the row below. This is so that you can follow the bead count shown above each chart and not have to count all the beads individually as you pick up a row.

Pay close attention to any reducing lines on the charts; these indicate differences in how to pass your wires through the row and how the row sits in relation to the row below.

BEAD COUNT

ROW

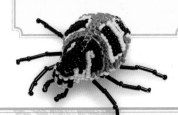

ADDING ROWS

From now on, you will add beads for one row at a time. It doesn't matter which wire end you thread beads onto as long as you read each row of the chart in the proper direction, as outlined below.

1 Following your chart, pick up the beads for row 3 onto the right wire, reading from right to left. If you want to add the beads onto the left wire, simply read the row from left to right instead.

2 Bend the wire and beads so that they sit on top of your previous rows and thread the empty wire through all of the beads in the newly added row. Pull tight.

3 As you continue to add rows, be sure that the new row is centered over the previous row—unless the new row has a reducing line (covered below) on the chart. The rows should be centered even if the size or number of beads you are adding alters.

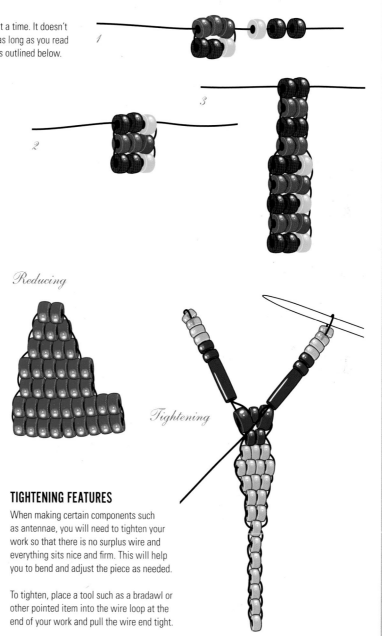

Reducing

Tightening

REDUCING

When making some shaped components such as wings, in addition to changing the number of beads from one row to the next, you may also want the new row to sit to one side or the other of the previous row. To achieve this you will use a technique called reducing. The rows that need reducing are marked with short red lines on the chart.

When reducing, note which end of the chart row has the reducing line and thread the new beads on starting from this end. When you thread the second wire through the new beads, exit the row between the beads separated by the red line on the chart rather than threading the wire through the entire row as usual.

TIGHTENING FEATURES

When making certain components such as antennae, you will need to tighten your work so that there is no surplus wire and everything sits nice and firm. This will help you to bend and adjust the piece as needed.

To tighten, place a tool such as a bradawl or other pointed item into the wire loop at the end of your work and pull the wire end tight.

STRAIGHTENING EDGES

On some items, such as wings, you will need to straighten an edge to align on one side. Simply adjust the edge with your fingers, or place the edge of the piece flat on your work surface and gently press to flatten the edge.

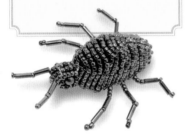

BACKSTITCHING

Backstitching adds extra strength to wings. Adding the extra wire allows you to bend and manipulate the beadwork once it is finished.

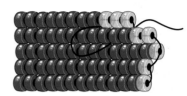

1

1 Pass one end of your wire through a row, exiting between two beads and below the two wires they are threaded onto. Thread the wire back into the work so that it loops above and around the wires you originally passed below.

2 Pull the wire so that it stays between the two beads and sits tightly around the wires they're threaded onto. Pass the wire through the beadwork so that it exits between two beads on the next row down, making sure the wire passes below the wires the beads sit on. Loop the working wire around the holding wires and pull tight. Continue working down the piece, row by row, as needed.

2

FINISHING WIRES

Finishing wires neatly is essential, not only to the look of your project, but also to ensure that the work does not come apart and that there are no sharp edges that could cause injury. Here are a few ways to finish wires.

SIMPLE TRIMMING AND BENDING
Once your wires are woven in enough to be secure, simply trim the wire ends approximately $\frac{1}{16}$ inch (2 mm) from the work and bend them back toward the work to hide.

HIDING WIRE ENDS
If you are making a 3-D piece, you can weave your wire ends to what will be the inside of the piece and trim, making sure that the ends will sit inside and not poke out.

Bend and trim

Hide the ends

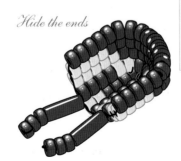

MIRROR REPEAT

When making pairs of items such as wings, you need to make sure that each one is a mirror image of the other. This can mean following charts from the other direction or placing wings on bodies with the same edges facing outward.

REPAIRING WIRE

Unfortunately, when working with fine wire it is almost inevitable that it will break when you least want it to. When this happens, continue working with the shorter remaining wire until it becomes unusable, then add in a new one. When adding in a new wire, you can choose to replace both ends of your old wire or just the broken one.

There are a few different methods you can use to add a new wire to your project and the one you choose may depend on whether or not you are able to weave through the previous rows. Whichever method you decide on, first get rid of the end of the old wire by trimming and bending.

THE PASSING THROUGH A ROW METHOD
You can add a new length of wire by simply centering it through the last row of beads added. This is ideal for when you want to replace both ends of the wire.

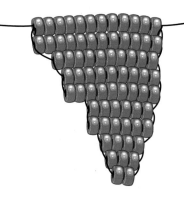

The passing through a row method

<div>

WORKING LEFT-HANDED

If you're left-handed, you will have no difficulties completing these projects; rows can be picked up on either wire end and charts can be read from left to right or right to left. Simply choose the way that works best for you, keeping an eye on the chart to be sure you reduce at the right points, and assemble finished items as instructed.

</div>

ASSEMBLY

When beginning to assemble your pieces, always look at the photograph of the finished item to see how the bug is put together, including how the wings sit, the antenna point, the legs lie, and so on.

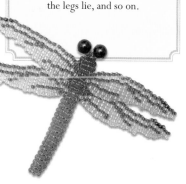

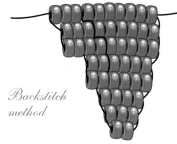

Backstitch method

Adding at the edge

THE BACKSTITCH METHOD
If some of the beads in the recent rows are too full to pass through, or you only want to add one side of wire, try this. Thread a length of wire through any beads available in your work. Hide one end of the wire inside a bead or at the edge of your work. Backstitch row by row, threading through beads as needed to move sideways, until you reach the spot where you need to start the new wire.

ADDING AT THE EDGE
If all of your beads are too full to pass a new wire through, you can simply add the new wire along the edge of your work by weaving through the loops at the ends of the rows until you reach the spot where you need to start a new wire. Trim and bend the beginning end of the wire to secure and hide.

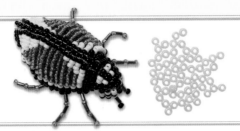

MATERIALS AND TOOLS

The materials that you use will have a big impact on the quality and size of your project as well as on the intensity of the color. Think carefully when making your choices as slight differences in quality may have a big effect when working on such a small scale.

BEADS

Beads come in all shapes and sizes. Most of the beads used in these projects come under the heading of "seed beads," which is a generic term for small round beads. As you buy and use beads, you will find that the sizes, colors, finishes, and quality vary from maker to maker and even by country of origin, with seed beads from some Japanese manufacturers widely regarded as the highest quality due to their consistency and uniformity in both size and color.

When working these projects you may find that choosing uniform beads will greatly help to keep your rows and work even. But be aware that even beads that come from the same manufacturer can vary from one color to another depending on their finishes and method of creating the color.

Also be aware when working with beads that not all finishes are permanent. Some, such as those coated with metals or "galvanized," may have finishes that can come off with simple contact with your skin, and others, such as dyed beads, can lose their color as you work with them or as they are exposed to sunlight. If you need advice, check with your bead seller.

The size of seed beads is indicated by a number, with 15, 11, and 8 being the most common sizes used. This size is called "aught" and originally referred to how many beads fitted on a one-inch length; therefore size 15s are smaller than 11s and 8s.

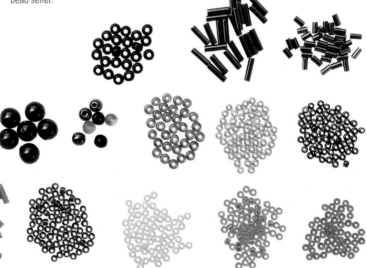

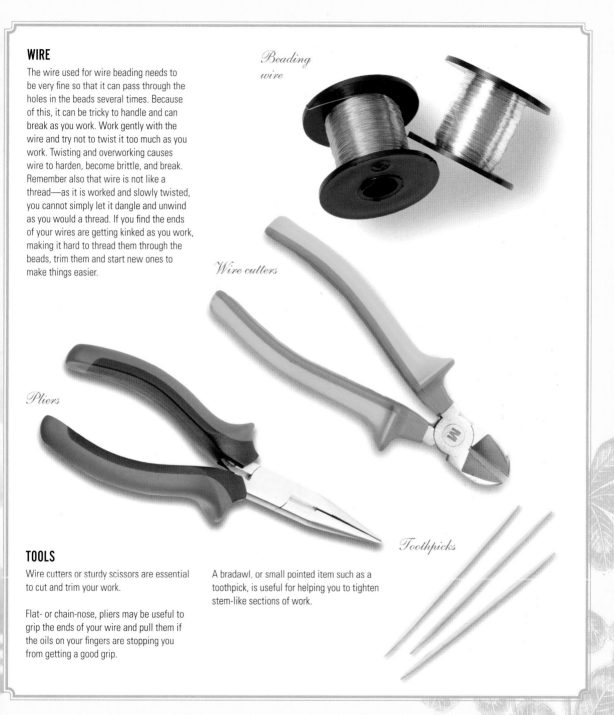

Beading wire

Wire cutters

Pliers

Toothpicks

WIRE

The wire used for wire beading needs to be very fine so that it can pass through the holes in the beads several times. Because of this, it can be tricky to handle and can break as you work. Work gently with the wire and try not to twist it too much as you work. Twisting and overworking causes wire to harden, become brittle, and break. Remember also that wire is not like a thread—as it is worked and slowly twisted, you cannot simply let it dangle and unwind as you would a thread. If you find the ends of your wires are getting kinked as you work, making it hard to thread them through the beads, trim them and start new ones to make things easier.

TOOLS

Wire cutters or sturdy scissors are essential to cut and trim your work.

Flat- or chain-nose, pliers may be useful to grip the ends of your wire and pull them if the oils on your fingers are stopping you from getting a good grip.

A bradawl, or small pointed item such as a toothpick, is useful for helping you to tighten stem-like sections of work.

EASTERN TAILED BLUE BUTTERFLY
Cupido comyntas

HABITAT *North America* **WINGSPAN** *⁷/₈ to 1 ¹/₈ inches (22 to 29 mm)*

You Will Need

5½ yd / 5 m of
32-gauge / 0.2 mm wire

104 aurora borealis light blue size 11
seed beads (approx. 1 g)

126 ceylon white size 11 seed beads
(approx. 1.25 g)

431 silver-lined blue size 11 seed beads
(approx. 4.25 g)

201 silver-lined dark blue size 11
seed beads (approx. 2 g)

2 silver-lined dark blue size 8
seed beads

2 silver-lined dark blue 6-mm
bugle beads

Wire cutters

Flat-nose pliers

Bradawl

A North American beauty, this butterfly is flat-beaded and fairly easy to create. It makes a great first project to introduce you to the basic techniques for making wire pieces, and the variations that follow will give you some ideas about experimenting with color, too.

MAKING THE TOP WINGS

1 Cut a 39-inch/1-m length of wire. Following the Top Wing chart on page 20, bead rows 1 and 2. Pull tight, keeping the beads flat and in the middle of the wire.

2 Continue following the chart to bead rows 3 through 14, being sure to keep your work the same side up all the time.

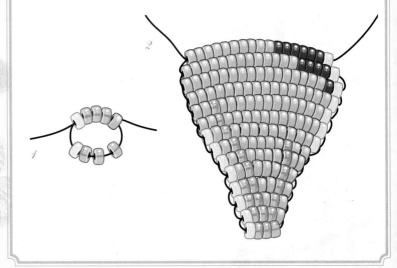

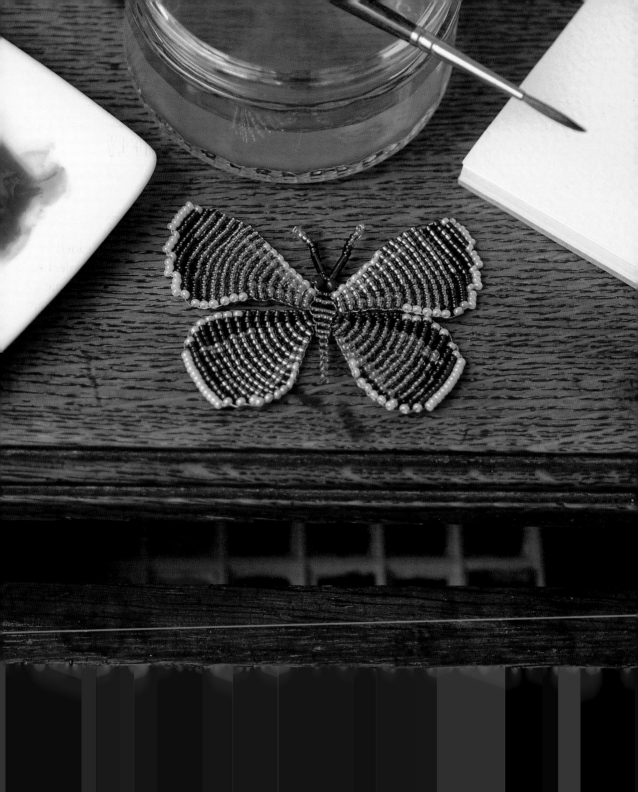

3 Follow the chart for row 15, but when passing the left wire reduce by bringing it out three beads before the end of the row, marked by a red line on the chart. Pull tight. This will reduce the side of the wing and give it its shape.

4 Repeat the reducing process for rows 16 and 17, exiting the rows of beads as marked on the chart for each.

5 Row 18 is the final row in the wing, and is worked the same way as rows 3 through 14. When row 18 is completed, straighten the top edge of the wing (the left side) by pressing it against your tabletop.

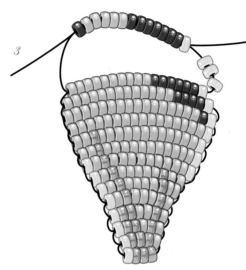

3

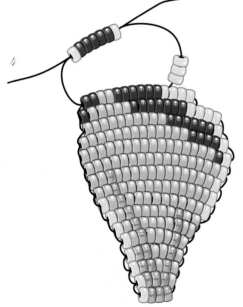

4

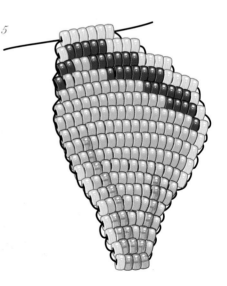

5

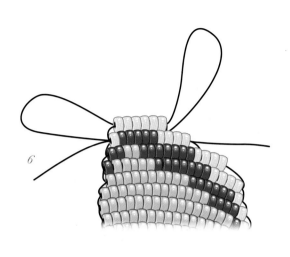

6

6 To finish the wire, thread both ends back into the beadwork; the left wire goes through all the beads in row 17, and the right wire enters the row between the third and fourth white beads and exits the left-hand end of the row.

7 Pass the wires back through row 16 in the same manner, then pull to tighten. Trim, bend, and hide the left wire. Use the right wire to start backstitching.

8 Pass the wire through between rows 14 and 15, then back through between rows 15 and 16. Pull the wire snug between the beads and around the two wires they're wrapping.

9 Continue backstitching down the center of the wing, finishing in the center of the first row, with two beads each side. Bend the wire back and thread it under one of the backstitches, then cut the end off. Your first top wing is complete; mirror repeat steps 1 through 9 to make a second top wing.

7

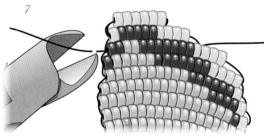

8

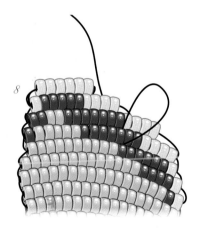

9

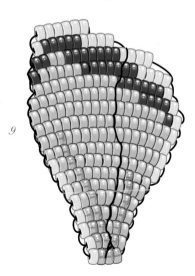

MAKING THE BOTTOM WINGS

10 Cut a 39-inch/1-m length of wire. Following the Bottom Wing chart on page 20, begin the first lower wing in exactly the same way you did the top one.

11 Continue through the rows until all are complete. Weave back through two rows, trim, bend, and hide the wires to finish.

12 Cut a 12-inch/30-cm length of wire and backstitch down the center of the wing, exactly as you did with the top wings. Mirror repeat steps 10 through 12 to make a second bottom wing.

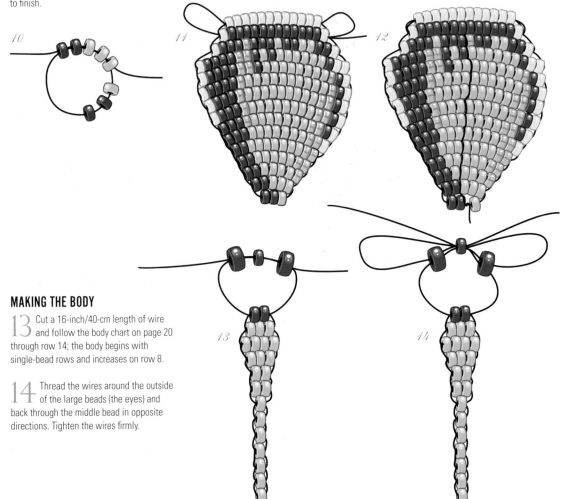

MAKING THE BODY

13 Cut a 16-inch/40-cm length of wire and follow the body chart on page 20 through row 14; the body begins with single-bead rows and increases on row 8.

14 Thread the wires around the outside of the large beads (the eyes) and back through the middle bead in opposite directions. Tighten the wires firmly.

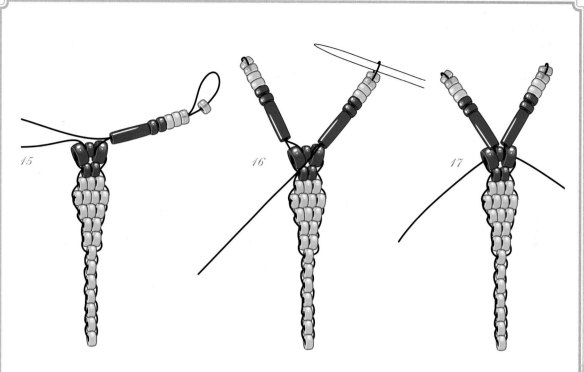

15 *16* *17*

15 To make the antennae, follow the chart on page 20 to thread beads onto the right wire, as shown. Thread the wire back down through all the beads except the last one. Repeat on the left wire.

16 To curve and tighten the antennae, put the point of a bradawl into the loop at the outer end of one antenna and pull the wire, pushing the beads tightly toward the head. Repeat on the other side.

17 Thread the wire from the left antenna back through the left eye bead from the center to the outer edge. Mirror repeat with the wire from the right antenna, feeding it back through the right eye bead. Pull both ends tight. Weave back through rows 13 and 12, trim, and bend the wires to finish.

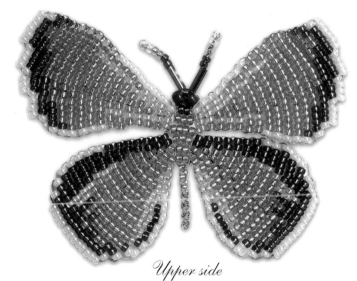

Upper side

ASSEMBLING THE BUTTERFLY

18 Cut a 12-inch/30-cm piece of wire, thread it through row 13 of the body, and center the body on the wire. Thread row 1 of a top wing onto each side, making sure that the longer edges of the wings face upward; pass each end of the wire through all four beads in row 11 on the body. Pull the wires tight.

19 Thread on the bottom wings, passing the wire through the three beads of row 1 of each wing and then back through row 9 of the body. Pull the wires tight, then weave one more row down, trim, and bend to finish.

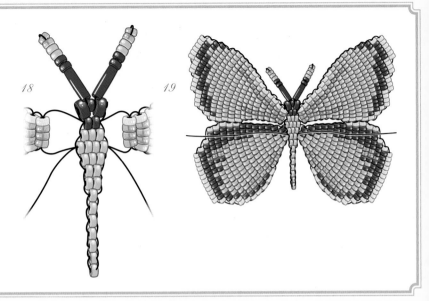

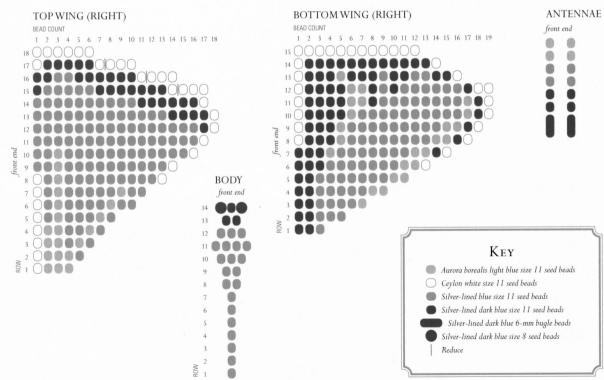

TOP WING (RIGHT)
BEAD COUNT

BOTTOM WING (RIGHT)
BEAD COUNT

ANTENNAE
front end

BODY
front end

KEY

- Aurora borealis light blue size 11 seed beads
- Ceylon white size 11 seed beads
- Silver-lined blue size 11 seed beads
- Silver-lined dark blue size 11 seed beads
- Silver-lined dark blue 6-mm bugle beads
- Silver-lined dark blue size 8 seed beads
- Reduce

HOBART'S RED GLIDER
Cymothoe hobarti

HABITAT *Africa* **WINGSPAN** *1 ⁵/₈ to 2 ⁵/₈ inches (42 to 68 mm)*

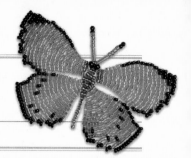

You Will Need

5½ yd / 5 m of
32-gauge / 0.2 mm wire

29 silver-lined brown size 11 seed beads

666 metallic red size 11 seed beads (approx. 6.75 g)

146 opaque black size 11 seed beads (approx. 1.5 g)

11 silver-lined dark green size 11 seed beads

2 opaque black size 8 seed beads

2 silver-lined brown 6-mm bugle beads

Wire cutters

Flat-nose pliers

Bradawl

Large areas of vivid red offset with tiny spots of black on this exquisite butterfly ensure that it's both simple and yet striking. Pin it onto plain black fabric to get the best effect.

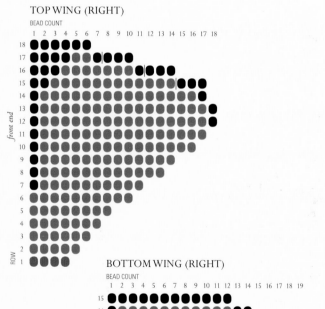

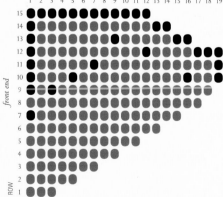

Key

Silver-lined brown size 11 seed beads

Metallic red size 11 seed beads

Opaque black size 11 seed beads

Silver-lined dark green size 11 seed beads

Opaque black size 8 seed beads

Silver-lined brown 6-mm bugle beads

Reduce

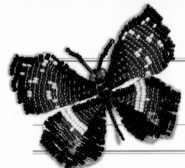

PURPLE EMPEROR
Apatura iris

HABITAT *Central Europe; UK* **WINGSPAN** *2 ³/₄ to 3 ⁵/₈ inches (70 to 92 mm)*

You Will Need

*5 ½ yd / 5 m of
32-gauge / 0.2 mm wire*

*369 matte black size 11 seed beads
(approx. 3.75 g)*

*294 silver-lined purple size 11
seed beads (approx. 3 g)*

*82 opaque white size 11 seed beads
(approx. 0.75 g)*

*87 opaque black size 11 seed beads
(approx. 0.75 g)*

*20 silver-lined orange size 11
seed beads*

2 silver-lined purple size 8 seed beads

2 opaque black 6-mm bugle beads

Wire cutters

Flat-nose pliers

Bradawl

The splendid purple livery of the male gives the Purple Emperor butterfly its name: the rich ground color is offset with contrasting patches of gold and white.

TOP WING (RIGHT)

BEAD COUNT
1 2 3 4 5 6 7 8 9 10 11 12 13 14 15 16 17 18

ROW / front end

BOTTOM WING (RIGHT)

BEAD COUNT
1 2 3 4 5 6 7 8 9 10 11 12 13 14 15 16 17 18 19

front end / ROW

ANTENNAE
front end

BODY

ROW

Key

- Matte black size 11 seed beads
- Silver-lined purple size 11 seed beads
- Opaque white size 11 seed beads
- Opaque black size 11 seed beads
- Silver-lined orange size 11 seed beads
- Silver-lined purple size 8 seed beads
- Opaque black 6-mm bugle beads
- | Reduce

ORANGE OAKLEAF
Kallima inachus

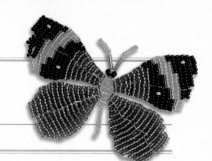

HABITAT *India; Japan; Taiwan* **WINGSPAN** *2 1/2 inches (64 mm)*

You Will Need

*5½ yd / 5 m of
32-gauge / 0.2 mm wire*

*518 silver-lined purple size 11
seed beads (approx. 5.25 g)*

*204 opaque black size 11 seed beads
(approx. 2 g)*

*90 silver-lined orange size 11
seed beads (approx. 1 g)*

4 opaque white size 11 seed beads

*36 silver-lined brown size 11
seed beads*

2 opaque black size 8 seed beads

2 silver-lined brown 6-mm bugle beads

Wire cutters

Flat-nose pliers

Bradawl

The Oakleaf takes its name from its underside, which is a replica of a leaf of the same name. It gives it amazing natural camouflage, but the attractive topside is better for beaders!

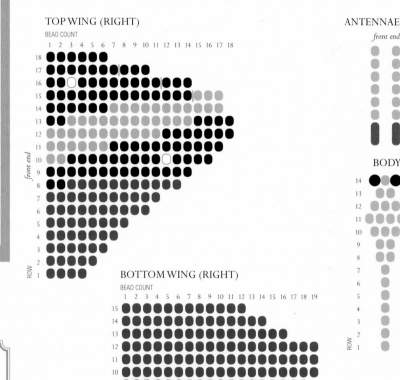

Key

- Silver-lined purple size 11 seed beads
- Opaque black size 11 seed beads
- Silver-lined orange size 11 seed beads
- Opaque white size 11 seed beads
- Opaque black size 8 seed beads
- Silver-lined brown 6-mm bugle beads
| Reduce

EMERALD PEACOCK SWALLOWTAIL
Papilio palinurus

HABITAT *Asia* **WINGSPAN** *3¹/₈ to 4 inches (80 to 100 mm)*

You Will Need

*5¹/₄ yd / 4.8 m of
32-gauge / 0.2 mm wire*

*439 opaque black size 11
seed beads (approx. 4.5 g)*

*232 opaque turquoise size 11
seed beads (approx. 2.25 g)*

*172 silver-lined dark green size 11
seed beads (approx. 1.75 g)*

*4 silver-lined turquoise 6-mm
bugle beads*

2 opaque black 6-mm bugle beads

2 opaque black size 8 seed beads

*4 transparent rainbow 6-mm
bugle beads*

Wire cutters

Flat-nose pliers

Bradawl

This dramatic butterfly uses more advanced methods, combining basic wire-weaving techniques with some more complicated shaping to create a colorful, patterned piece of work that is ideal for showing off your newly acquired skills.

GETTING STARTED

1 Cut a 16-inch/40-cm length of wire. Following the Body chart on page 28, bead rows 1 through 11.

2 Pass the wires around the outside of the eyes (the two size 8 seed beads) and through the middle bead in opposite directions. Thread two transparent rainbow bugle beads and one black seed bead onto one wire. Skip the seed bead and pass the wire back through the bugle beads. Mirror repeat on the other wire.

3 Thread the wire from the left antenna through the left eye bead, from the center to the outside edge. Weave, trim, and bend the wire to finish. Mirror repeat with the right antenna.

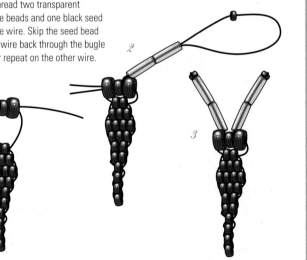

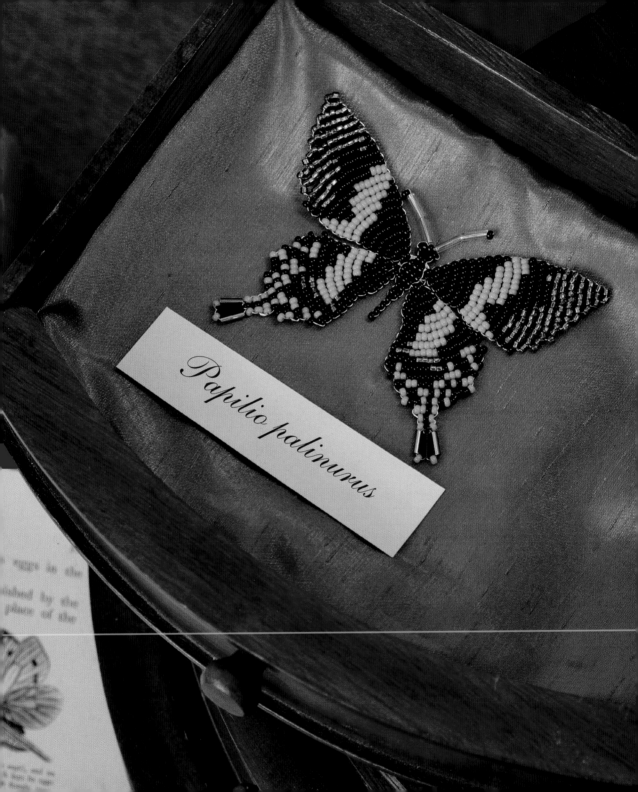

Papilio palinurus

MAKING THE TOP WINGS

4 Cut a 39-inch/1-m length of wire. Following the Top Wing chart on page 28, bead rows 1 through 13. On row 14, reduce as shown on the chart and pull tight.

5 Add the remaining rows, reducing as you go where the red lines appear on the chart. Straighten the top edge of the wing (the left side) by pressing it against your tabletop.

6 Weave, trim, and bend one wire to finish. Use the other wire to backstitch the wing. Make a second wing in the same manner, but work the backstitching on the other side so that the wings are a pair.

MAKING THE BOTTOM WINGS

7 Cut a 39-inch/1-m length of wire. Following the Bottom Wing chart on page 28, bead rows 1 through 18, making sure you reduce on rows 10 through 15 as shown. Thread one turquoise bugle and one seed bead on each wire, thread both wires through a black bugle, and push all beads tight to the wing.

8 Nudge the black bugle inward so that it lies flat between the turquoise bugles. Thread the right wire through the right side of the black seed bead in row 18, then through the turquoise seed bead next to it. Pull tight, then mirror repeat with the left wire. Weave the wires through the next two rows. Bend, trim, and hide one wire.

9 Backstitch down the wing with the other wire. Repeat all steps to make a second wing, backstitching down the opposite side of the wing to make a pair.

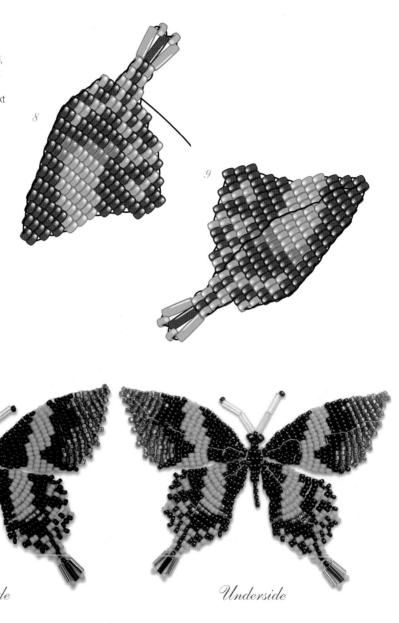

Upper side

Underside

ASSEMBLING THE BUTTERFLY

10 Cut a 16-inch/40-cm length of wire. Center the body on the wire, threading through row 9. Thread a top wing through row 1 onto each wire end, making sure that the flat edges are at the top. Pass the wires through row 8 of the body, back through row 1 of the wings, and through row 10 of the body. Pull tight.

11 Pass the wires down through row 1 of the top wings again and thread on the bottom wings through row 1. Thread the wires through row 7 of the body, then through row 8. Cut the wires $^1/_{16}$ inch/2 mm from the work and bend them toward the tail to finish.

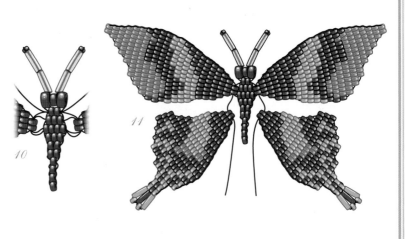

TOP WING (RIGHT)
BOTTOM WING (RIGHT)
ANTENNAE
front end
BODY
front end

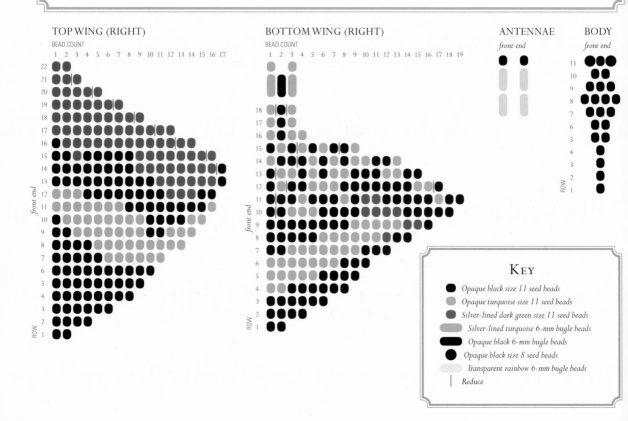

KEY

- ● Opaque black size 11 seed beads
- ● Opaque turquoise size 11 seed beads
- ● Silver-lined dark green size 11 seed beads
- ▬ Silver-lined turquoise 6-mm bugle beads
- ▬ Opaque black 6-mm bugle beads
- ● Opaque black size 8 seed beads
- ▮ Transparent rainbow 6-mm bugle beads
- | Reduce

MALABAR BANDED PEACOCK
Papilio buddha

HABITAT *India* **WINGSPAN** *4 1/4 to 6 1/8 inches (107 to 155 mm)*

Gorgeous green and aqua bands of beading give you a good idea of how lovely this butterfly looks in the wild. Silver-lined beads mimic the iridescence of real insects perfectly.

You Will Need

5 1/4 yd / 4.8 m of 32-gauge / 0.2 mm wire

179 silver-lined green size 11 seed beads (approx. 1.75 g)

354 ceylon aqua size 11 seed beads (approx. 3.5 g)

310 opaque black size 11 seed beads (approx. 3 g)

10 opaque black 6-mm bugle beads

2 opaque black size 8 seed beads

Wire cutters

Flat-nose pliers

Bradawl

KEY

- Silver-lined green size 11 seed beads
- Ceylon aqua size 11 seed beads
- Opaque black size 11 seed beads
- Opaque black 6-mm bugle beads
- Opaque black size 8 seed beads
- | Reduce

TOP WING (RIGHT)

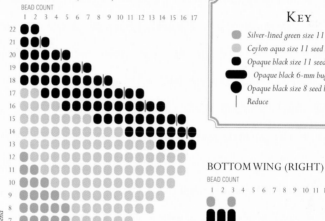

BOTTOM WING (RIGHT)

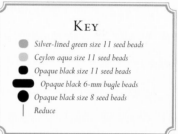

ANTENNAE

front end

BODY

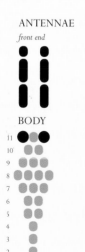

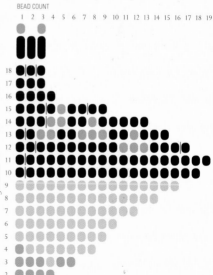

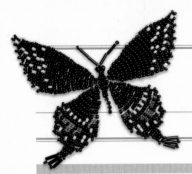

BLACK SWALLOWTAIL
Papilio polyxenes

HABITAT *North America* **WINGSPAN** *3 1/8 to 4 3/8 inches (80 to 110 mm)*

The most dramatic coloring belongs to the male Black Swallowtail; the female tends to have a more subtle wing palette, with pale rather than bright yellow spots.

YOU WILL NEED

5¼ yd / 4.8 m of 32-gauge / 0.2 mm wire

755 opaque black size 11 seed beads (approx. 7.5 g)

60 opaque cream size 11 seed beads (approx. 0.5 g)

28 blue-lined aqua size 11 seed beads

10 opaque black 6-mm bugle beads

2 opaque black size 8 seed beads

Wire cutters

Flat-nose pliers

Bradawl

KEY

- ● Opaque black size 11 seed beads
- ○ Opaque cream size 11 seed beads
- ● Blue-lined aqua size 11 seed beads
- ▬ Opaque black 6-mm bugle beads
- ● Opaque black size 8 seed beads
- | Reduce

TOP WING (RIGHT)

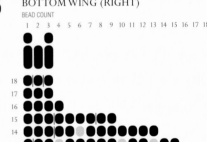

BOTTOM WING (RIGHT)

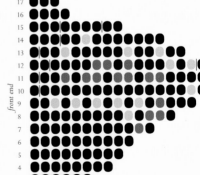

ANTENNAE

front end

BODY

AFRICAN SWALLOWTAIL
Papilio dardanus

HABITAT *Africa* **WINGSPAN** *4 to 4 3/8 inches (100 to 120 mm)*

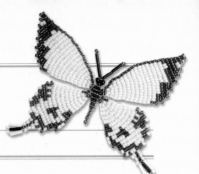

You Will Need

*5¼ yd / 4.8 m of
32-gauge / 0.2 mm wire*

*271 transparent brown size 11
seed beads (approx. 2.75 g)*

*572 matte opaque cream size 11
seed beads (approx. 5.75 g)*

4 opaque cream 6-mm bugle beads

6 opaque black 6-mm bugle beads

2 opaque black size 8 seed beads

Wire cutters

Flat-nose pliers

Bradawl

So large is this butterfly that it's sometimes colloquially known as "the flying handkerchief"—an impression that's supported by its creamy wings outlined with neat dark edges.

TOP WING (RIGHT)

BEAD COUNT

KEY

- ● Transparent brown size 11 seed beads
- ● Matte opaque cream size 11 seed beads
- ● Opaque cream 6-mm bugle beads
- ▬ Opaque black 6-mm bugle beads
- ● Opaque black size 8 seed beads
- | Reduce

BOTTOM WING (RIGHT)

BEAD COUNT

ANTENNAE

front end

BODY

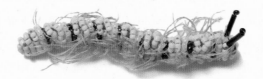

SOUTHERN DOGFACE CATERPILLAR
Zerene cesonia

HABITAT *Central America; North America; South America* LENGTH *1½ inches (39 mm)*

If you want a simple beading project, one of the caterpillars in this section is a good choice—they're made from long strips of beading, and when you've made one or two you can try varying the numbers of beads to add waves and extra structure.

You Will Need

3½ yd / 3.15 m of 32-gauge / 0.2 mm wire

39 in / 1 m of green 6-strand embroidery floss

300 opaque light green size 11 seed beads (approx. 3 g)

128 ceylon white size 11 seed beads (approx 1.25 g)

80 iris emerald green size 11 seed beads (approx. 0.75 g)

2 opaque black size 8 seed beads

2 opaque black 6-mm bugle beads

Wire cutters

Flat-nose pliers

Sewing needle

STARTING THE BODY

1 Cut a 39-inch/1-m length of wire. Following the Side of Body chart on page 36, make a flat strip of beadwork.

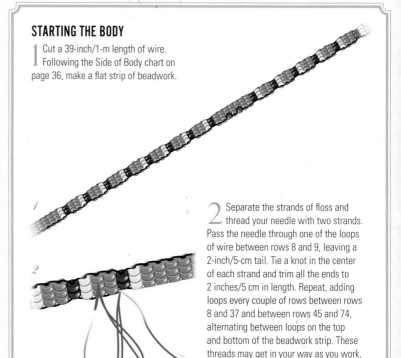

2 Separate the strands of floss and thread your needle with two strands. Pass the needle through one of the loops of wire between rows 8 and 9, leaving a 2-inch/5-cm tail. Tie a knot in the center of each strand and trim all the ends to 2 inches/5 cm in length. Repeat, adding loops every couple of rows between rows 8 and 37 and between rows 45 and 74, alternating between loops on the top and bottom of the beadwork strip. These threads may get in your way as you work, but it is a lot easier to add them now than later on.

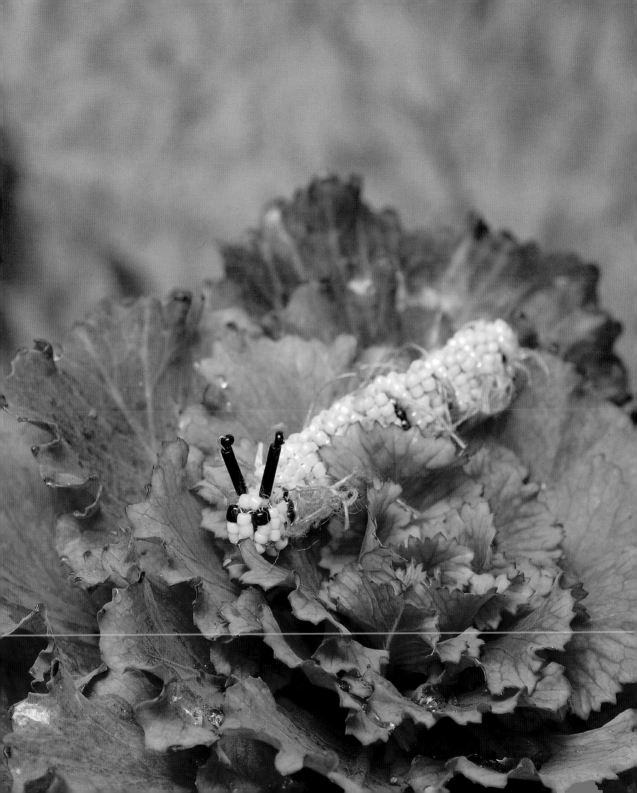

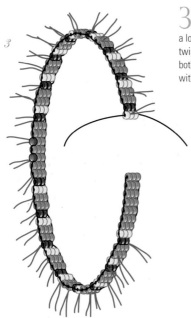

3 Bring the two ends of the work together and weave back through row 1 to form a loop, making sure that the work isn't twisted. Weave, trim, and bend to finish both wires securely. The side of the loop with the larger beads (the eyes) is the top.

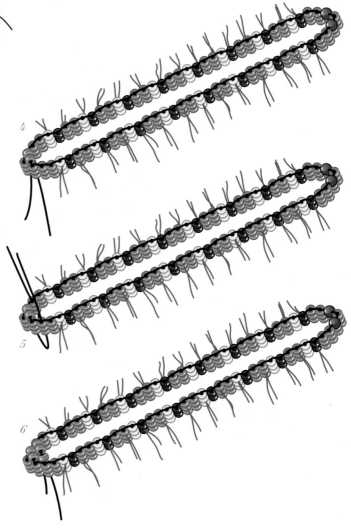

MAKING THE BODY TOP

4 Cut a 39-inch/1-m length of wire and thread two light green seed beads. Insert the wire from the top of the body through rows 3 and 5. This is row 1 of the top of the body.

5 Weave the wires back through rows 2 and 6 and pull tight.

6 Follow the Top and Bottom of Body chart on page 36 to bead rows 2 through 36 by crossing through the beads, passing down through a row and then up through the next row to be in position to continue. Pull tight as you work to turn the round loop of beadwork into a long, narrow loop. Weave, trim, and bend to finish both wires securely.

MAKING THE BODY BOTTOM

7 Cut a 39-inch/1-m length of wire and thread two light green seed beads. Pass the wire under the loops between rows 5 and 4 and between rows 4 and 3 on the bottom of the body. Center the beadwork on the wire.

8 Cross the wires inside the two beads and then wind them around the next loops of wire between rows 3 and 2 and between rows 5 and 6.

9 Bead rows 2 through 36 of the Top and Bottom of Body chart, making sure that you thread each end of the wire through the beads and then under the next loop along the base of the beadwork. Weave, trim, and bend to finish both wires securely.

ADDING THE MANDIBLES

10 Cut a 6-inch/15-cm length of wire. Thread the body onto the center of the wire, through row 35 of the top of the body.

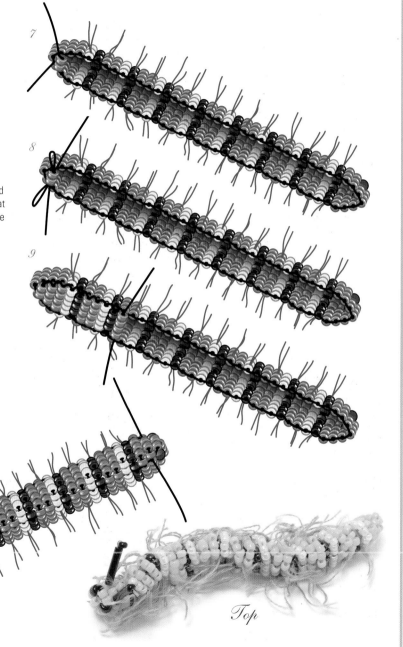

Top

11 On one of the wire ends, thread a bugle and a black seed bead. Skip the seed bead and pass the wire back through the bugle bead and into the two beads in row 35 that your wire wasn't exiting. Weave this wire into your work, trim, and hide. Repeat with the other wire to finish. If wanted, trim the threads down to 1-inch/2.5-cm lengths.

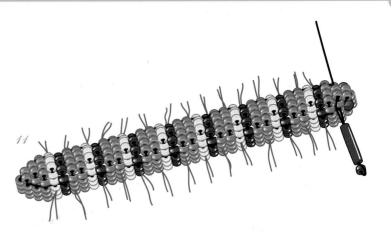

SIDE OF BODY

ROW

1 2 3 4 5 6 7 8 9 10 11 12 13 14 15 16 17 18 19 20 21 22 23 24 25 26 27 28 29 30 31 32 33 34 35 36 37

BEAD COUNT 1 2 3

ROW

38 39 40 41 42 43 44 45 46 47 48 49 50 51 52 53 54 55 56 57 58 59 60 61 62 63 64 65 66 67 68 69 70 71 72 73 74

1 2 3 BEAD COUNT

front end

TOP AND BOTTOM OF BODY

ROW

1 2 3 4 5 6 7 8 9 10 11 12 13 14 15 16 17 18 19 20 21 22 23 24 25 26 27 28 29 30 31 32 33 34 35 36

BEAD COUNT 1 2 3 4 5

front end

MANDIBLES

BROWN HOODED OWLET MOTH CATERPILLAR
Cucullia convexipennis

HABITAT *North America* **LENGTH** *1 ³/₄ inches (45 mm)*

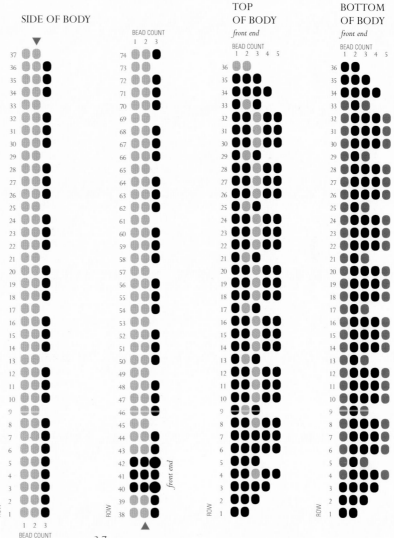

This little beast only keeps his brilliant coloring as a caterpillar—in adulthood, he's just a sober brown moth.

YOU WILL NEED

3½ yd / 3.15 m of 32-gauge / 0.2 mm wire

144 opaque yellow luster size 11 seed beads (approx. 1.5 g)

280 matte black size 11 seed beads (approx. 2.75 g)

2 opaque black size 8 seed beads

2 opaque black 6-mm bugle beads

27 silver-lined orange size 11 seed beads

59 transparent red size 11 seed beads (approx. 0.5 g)

Wire cutters

Flat-nose pliers

KEY

- Opaque yellow luster size 11 seed beads
- Matte black size 11 seed beads
- Opaque black size 8 seed beads
- Opaque black 6-mm bugle beads
- Silver-lined orange size 11 seed beads
- Transparent red size 11 seed beads
- ▲ Join

** This is a hairless caterpillar, so after you've made the side of the body, skip step 2 and move straight on to step 3.*

MANDIBLES

SIDE OF BODY

TOP OF BODY — *front end*

BOTTOM OF BODY — *front end*

BEAD COUNT

ALDER MOTH CATERPILLAR
Acronicta alni

HABITAT *Asia; Europe* **LENGTH** *1 1/8 to 1 3/8 inches (30 to 35 mm)*

This is one of the most elegant of the "hairy" caterpillars, with feather-like top hairs and clean yellow-and-black striping.

YOU WILL NEED

3 1/2 yd / 3.15 m of 32-gauge / 0.2 mm wire

39 in / 1 m of black 6-strand embroidery floss

390 opaque black size 11 seed beads (approx. 4 g)

120 opaque yellow luster size 11 seed beads (approx 1.25 g)

2 opaque black size 8 seed beads

2 opaque black 6-mm bugle beads

Wire cutters

Flat-nose pliers

Sewing needle

KEY

- ● *Opaque black size 11 seed beads*
- ● *Opaque yellow luster size 11 seed beads*
- ● *Opaque black size 8 seed beads*
- ▬ *Opaque black 6-mm bugle beads*
- ▲ *Join*

MANDIBLES

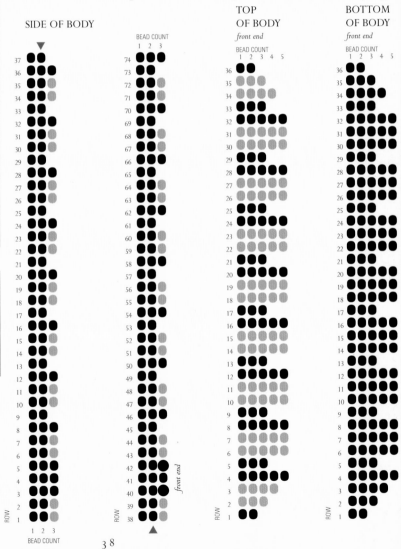

SIDE OF BODY

TOP OF BODY
front end

BOTTOM OF BODY
front end

AUSTRALIAN GRAPEVINE MOTH CATERPILLAR
Phalaenoides glycinae

HABITAT *Australia* **LENGTH** *1⁹/₁₆ inches (40 mm)*

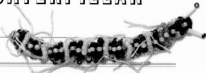

The black and white grid looks as though it has been drawn on with a fine pen, and is enlivened with touches of orangey-red.

YOU WILL NEED

3½ yd / 3.15 m of 32-gauge / 0.2 mm wire

39 in / 1 m of cream 6-strand embroidery floss

244 matte black size 11 seed beads (approx. 2.5 g)

170 ceylon pale yellow size 11 seed beads (approx. 1.75 g)

20 silver-lined orange size 11 seed beads

76 transparent red size 11 seed beads (approx. 0.75 g)

2 opaque black size 8 seed beads

2 ceylon cream 6-mm bugle beads

Wire cutters

Flat-nose pliers

Sewing needle

KEY

- Matte black size 11 seed beads
- Ceylon pale yellow size 11 seed beads
- Silver-lined orange size 11 seed beads
- Transparent red size 11 seed beads
- Opaque black size 8 seed beads
- Ceylon cream 6-mm bugle beads
- ▲ Join

● ● MANDIBLES

SIDE OF BODY

TOP OF BODY — *front end*

BOTTOM OF BODY — *front end*

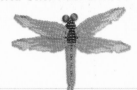

FLAME SKIMMER DRAGONFLY
Libellula saturata

HABITAT *North America* **LENGTH** *2 1/16 to 2 7/16 inches (52 to 61 mm)*

You Will Need

*7 yd/6.35 m of
32-gauge/0.2 mm wire*

*297 opaque orange size 11 seed beads
(approx. 3 g)*

*180 transparent orange size 11
seed beads (approx. 1.75 g)*

*140 aurora borealis crystal size 11
seed beads (approx. 1.5 g)*

*101 silver-lined brown size 11
seed beads (approx. 1 g)*

*2 matte brown 6-mm diameter
pearl beads*

Wire cutters

Flat-nose pliers

Dazzling and shapely, this beaded dragonfly design combines the basic wire-weaving technique with more advanced reducing and lacing to create four wings around a compact body. Most of the examples make use of transparent beads to echo the ethereal impression left by the originals.

MAKING THE WINGS

1 Cut a 39-inch/1-m length of wire. Following the Wing chart on page 45, bead rows 1 through 14.

2 When you reach row 15, reduce by threading the needed beads onto the right wire, but thread the left wire through only the first five of them. Pull tight.

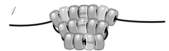

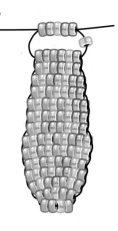

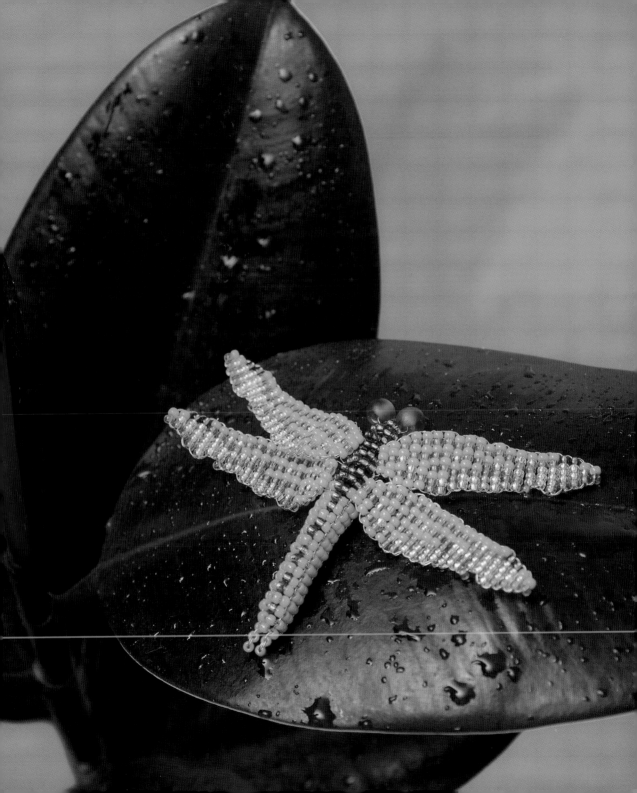

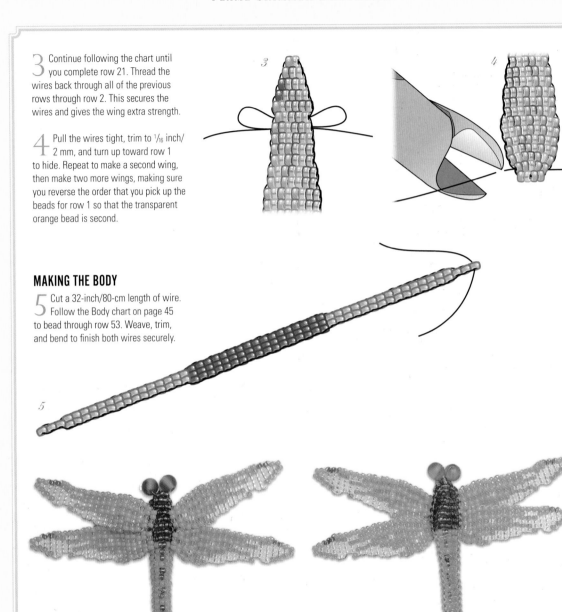

3 Continue following the chart until you complete row 21. Thread the wires back through all of the previous rows through row 2. This secures the wires and gives the wing extra strength.

4 Pull the wires tight, trim to ¹/₁₆ inch/ 2 mm, and turn up toward row 1 to hide. Repeat to make a second wing, then make two more wings, making sure you reverse the order that you pick up the beads for row 1 so that the transparent orange bead is second.

MAKING THE BODY

5 Cut a 32-inch/80-cm length of wire. Follow the Body chart on page 45 to bead through row 53. Weave, trim, and bend to finish both wires securely.

Upper side

Underside

LACING THE BODY

6 Thread a 35-inch/90-cm length of wire
through rows 26 and 28 of the body;
these are the rows on each side of the
center brown body row. Pull the wire
through so that the body is centered on it.

7 Following the Lacing Beads chart on
page 45, thread three brown beads
for the first row. Pass both wires back into
rows 26 and 28 of the main body. Pinch the
three beads between your index finger and
thumb and pull the wires tight with your
other hand. The beads will slide up against
the body strip.

6

7

8

8 Thread the wires back through the
body so that one exits row 25 and the
other exits row 29.

9 Continue adding rows of beads
following the Lacing Beads chart,
moving along the body one row at a time.
As you work, pull each row tightly so that
the strip you originally made bends into a
U shape.

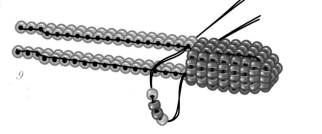

9

10 When you've finished row 24 of
the Lacing Beads chart, weave
the wires into the work to secure, trim,
and finish.

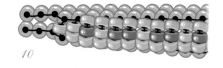

10

ADDING THE EYES

11 Cut a 10-inch/25-cm length of wire and bend it gently in half. Thread the ends up through the rows of beads on each side of the centrer row at the front of the body. Make sure that the wires come out of the top of the head.

12 Thread a large pearl bead onto each wire and pass them, one at a time, down through the centrer row.

13 Weave the wires into the work to secure, then bring them together and twist. Trim the wires to 3/16 inch/ 5 mm and tuck inside the body to hide.

ASSEMBLING THE DRAGONFLY

14 Cut a 16-inch/40-cm piece of wire. From the top of the head, count down to the fourth row of brown beads and thread the wire through the center two beads of this row. Center the body on the wire and thread one wing onto each wire, making sure that the flat edge of each wing is facing forward.

15 Wind the wires around the loops on the edge of the body strip between the sixth and seventh rows from the top of the body. Pull tightly. Thread another wing onto each wire.

16 Wind the wires around the loops on the body another two rows down. Thread the wires inside the body, twist together to secure them, and trim.

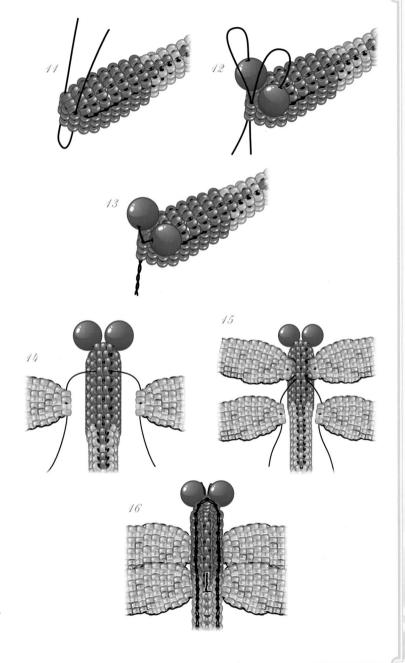

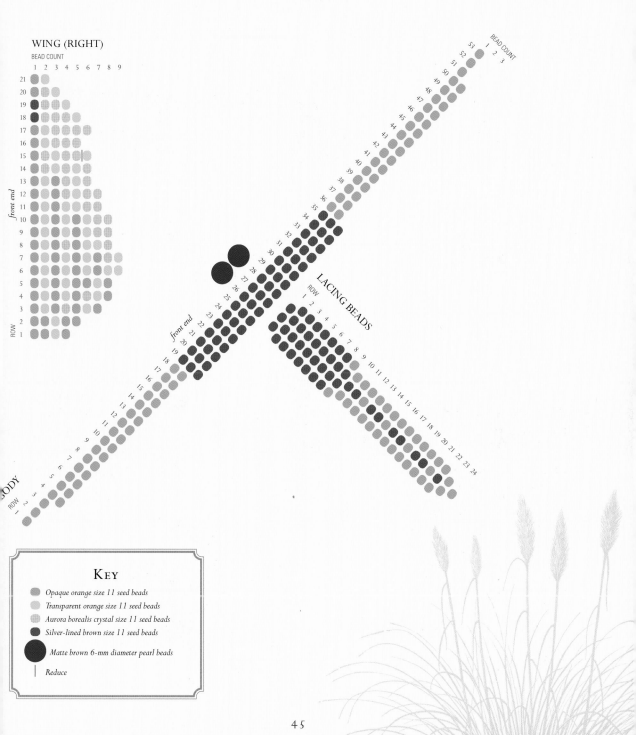

WING (RIGHT)

BEAD COUNT

BEAD COUNT

front end

ROW

LACING BEADS

ROW

front end

BODY

ROW

KEY

Opaque orange size 11 seed beads

Transparent orange size 11 seed beads

Aurora borealis crystal size 11 seed beads

Silver-lined brown size 11 seed beads

Matte brown 6-mm diameter pearl beads

Reduce

HOARY SKIMMER DRAGONFLY
Libellula nodisticta

HABITAT *North America* **LENGTH** *1³/₄ to 2¹/₁₆ inches (46 to 52 mm)*

You Will Need

*7 yd / 6.35 m of
32-gauge / 0.2 mm wire*

*70 translucent navy blue size 11
seed beads (approx. 0.75 g)*

*94 frosted pale blue size 11 seed beads
(approx. 1 g)*

*392 ceylon mixed pastel colors size 11
seed beads (approx. 4 g)*

*140 translucent blue size 11 seed beads
(approx. 1.5 g)*

*22 silver-lined dark yellow size 11
seed beads*

*2 metallic brown 6-mm diameter
pearl beads*

Wire cutters

Flat-nose pliers

Key

● Translucent navy blue size 11 seed beads
● Frosted pale blue size 11 seed beads
● Ceylon mixed pastel colors size 11 seed beads
● Translucent blue size 11 seed beads
● Silver-lined dark yellow size 11 seed beads

⬤ *Metallic brown 6-mm diameter pearl beads*

| *Reduce*

With touches of orange on the body and clear blue wings, the Hoary Skimmer is found all over the U.S.A.

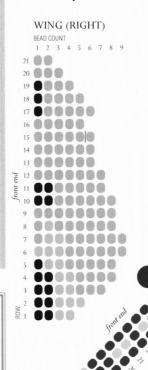

WING (RIGHT)

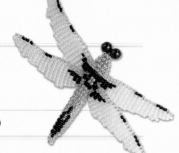

FOUR-SPOTTED SKIMMER
Libellula quadrimaculata

HABITAT *Asia; Europe; North America* **LENGTH** *1¹/₂ to 1⁷/₈ inches (39 to 48 mm)*

Neat black blotches add definition to this otherwise ethereally golden member of the Skimmer family.

You Will Need

7 yd/6.35 m of 32-gauge/0.2 mm wire

154 silver-lined dark yellow size 11 seed beads (approx. 1.5 g)

94 opaque black size 11 seed beads (approx. 1 g)

372 ceylon cream size 11 seed beads (approx. 3.75 g)

98 metallic gold size 11 seed beads (approx. 1 g)

2 metallic brown 6-mm diameter pearl beads

Wire cutters

Flat-nose pliers

Key

- Silver-lined dark yellow size 11 seed beads
- Opaque black size 11 seed beads
- Ceylon cream size 11 seed beads
- Metallic gold size 11 seed beads
- Metallic brown 6-mm diameter pearl beads
- | Reduce

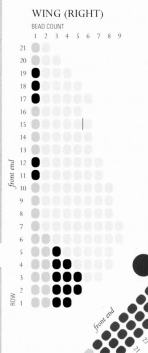

WING (RIGHT)

BODY

LACING BEADS

CARDINAL MEADOWHAWK
Sympetrum illotum

HABITAT *Central America; North America; South America* **LENGTH** *1¹/₂ to 1⁹/₁₆ inches (38 to 40 mm)*

Red and clear beads imitate the fragile netted wings that give this dragonfly its light-as-air appeal.

You Will Need

*7 yd/6.35 m of
32-gauge/0.2 mm wire*

*312 silver-lined bright red size 11
seed beads (approx. 3 g)*

*316 transparent clear rainbow size 11
seed beads (approx. 3 g)*

*8 metallic dark copper size 11
seed beads*

*82 silver-lined red size 11 seed beads
(approx. 0.75 g)*

*2 metallic brown 6-mm diameter
pearl beads*

Wire cutters

Flat-nose pliers

Key

Silver-lined bright red size 11 seed beads

Transparent clear rainbow size 11 seed beads

Metallic dark copper size 11 seed beads

Silver-lined red size 11 seed beads

Metallic brown 6-mm diameter pearl beads

| Reduce

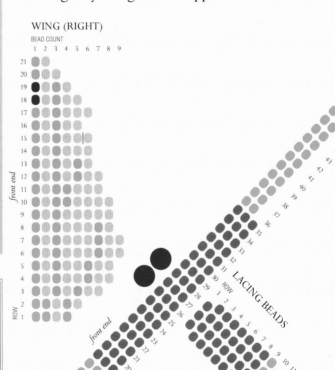

WING (RIGHT)

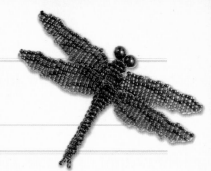

BANDED DEMOISELLE
Calopteryx splendens

HABITAT *Europe; Asia* **LENGTH** *1 ⅝ to 1 ¾ inches (42 to 45 mm)*

The simplest way to catch the scintillating effect of this insect is to use iridescent beads that catch and reflect the light.

You Will Need

7 yd / 6.35 m of
32-gauge / 0.2 mm wire

406 rainbow iridescent black size 11
seed beads (approx. 4 g)

312 rainbow iridescent brown size 11
seed beads (approx. 3 g)

2 metallic purple 6-mm diameter
pearl beads

Wire cutters

Flat-nose pliers

Key

● *Rainbow iridescent black size 11 seed beads*

● *Rainbow iridescent brown size 11 seed beads*

● *Metallic purple 6-mm diameter pearl beads*

| *Reduce*

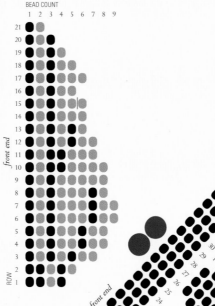

ORANGE SPOTTED TIGER MOTH
Amata annulata

HABITAT *Australia* **WINGSPAN** *1½ inches (40 mm)*

YOU WILL NEED

*6½ yd / 5.9 m of
32-gauge / 0.2 mm wire*

*519 opaque black size 11
seed beads (approx. 5.25 g)*

*126 silver-lined brown size 11
seed beads (approx. 1.25 g)*

2 opaque black size 8 seed beads

20 opaque black 6-mm bugle beads

6 opaque black 3-mm bugle beads

6 opaque white size 11 seed beads

*106 silver-lined orange size 11
seed beads (approx. 1 g)*

Wire cutters

Flat-nose pliers

Bradawl

This pattern combines intricate lacing techniques with a fully beaded body: the result is both pretty and a sturdy piece that will easily stand up to wear if you want to press it into service as a key fob or mounted on a brooch backing.

MAKING THE BODY

1 Cut a 28-inch/70-cm length of wire. Following the Side of Body chart on page 55, bead rows 1 through 42. Form the piece into a loop by threading both wires through the first row again. Pull tightly, then weave through the next row of black beads, trim, and bend the wires.

2 Cut a 43-inch/1.1-m length of wire and gently bend it in half. Thread the ends through rows 25 and 27.

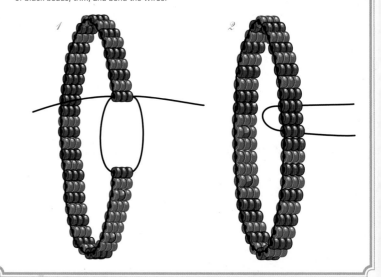

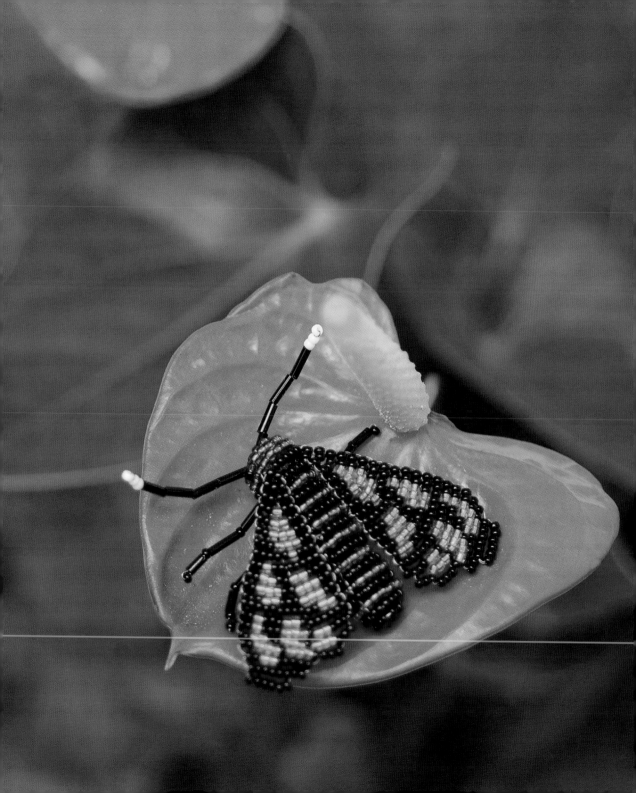

3 Thread on three black beads on one end of the wire, then pass the other end back through the three black beads in the opposite direction. Push the wire ends back down through rows 25 and 27. Hold the beads between your thumb and finger and pull the wires tight.

4 Thread the wires through rows 24 and 28 to be back in position to start row 2.

5 Continue following the Top of Body chart on page 55 to bead rows 2 through 20. You will end up with wires coming down out of the rows on each side of the center row in the side of the body.

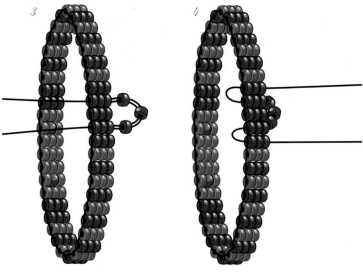

6 Thread four black bugle and three white seed beads onto each wire for the antennae. Skip the last seed bead and pass each wire back through two seed and four bugle beads and into the work. Place a bradawl in the end loop of wire and tighten the wire.

7 Thread both wires into the center row of the body. Wind them in opposite directions around the wire of row 20 of the top of the body, on each side of the center bead. Thread the wires inside, trim, and hide.

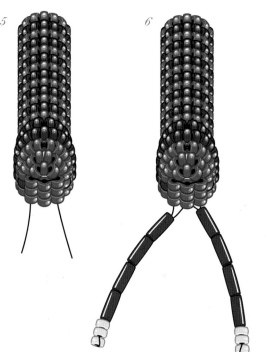

MAKING THE WINGS

8 Cut a 39-inch/1-m length of wire. Following the Wing chart on page 55, bead rows 1 through 20, reducing where indicated on rows 15, 16, 17, and 19. Weave the wires back through three rows. Trim and bend to finish one wire, leaving the other.

9 Use the remaining wire to backstitch down the wing, ending between the two beads on row 1. Weave, trim, and bend to finish the wire. Mirror repeat to make a second wing.

ADDING THE WINGS

10 Cut an 8-inch/20-cm piece of wire. Thread the wire through the middle five beads of row 17 of the top of the body and center the body on the wire. Thread a wing onto each wire, with the slightly longer side of each wing at the top, and pass the wire ends through the middle four beads of row 16. Weave through row 17, the end row of the wings, and row 16 again. Trim and bend inside the body to hide.

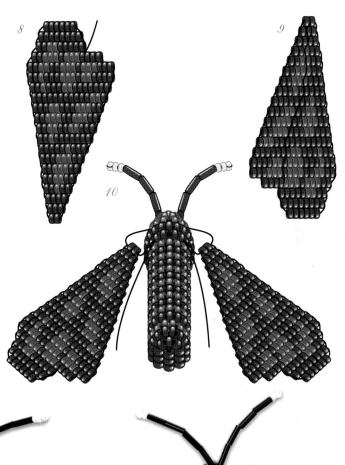

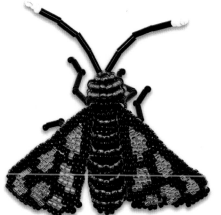

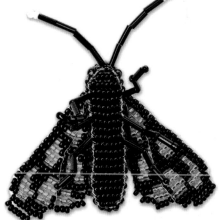

Upper side

Underside

FINISHING THE BODY

11 Thread an 8-inch/20-cm length of wire through the middle five beads of row 10 on the top of the body and center the body on the wire. Wind the wire around the loops between rows 7 and 8 on each wing, then thread back into the body beads. Bend the wire ends inside the body, twist them together, and trim.

12 Cut a 39-inch/1-m length of wire, thread four black seed beads, and center them on the wire. Thread one wire under the wire loops between rows 3 and 4 and the other between rows 6 and 7.

13 Thread the wires back through the four beads in opposite directions, then behind the wire loops that are the next row down along the edge of the body. Pull tight.

14 Following the Belly chart on page 55, bead rows 2 and 3. Following the Legs chart on page 55, add one leg onto each wire, then skip the last bead added and pass the wire down through the other five. Bead row 4 onto one wire. Thread the other wire in the opposite direction through row 4 and behind the wire loops on the edge of the body, one row down. Pull tight. Continue beading the belly, adding legs when indicated. After row 18, weave back through rows 17 and 16 rather than threading the wires into the next loops down. Trim and bend the wires to hide.

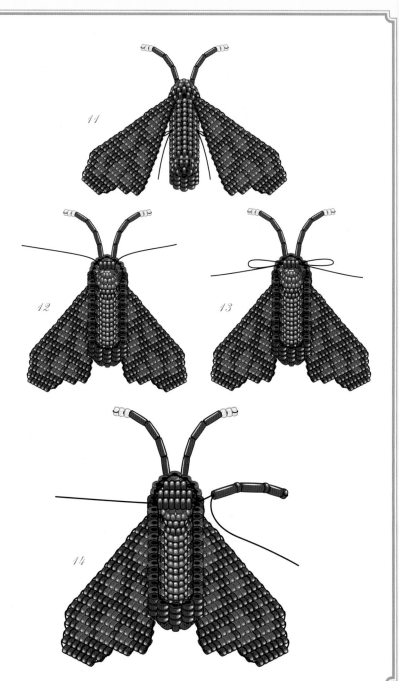

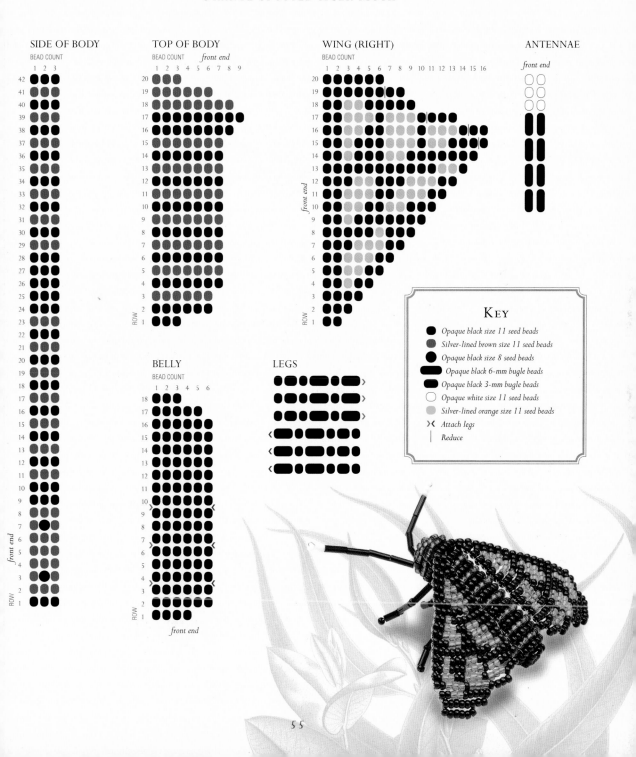

SIDE OF BODY

TOP OF BODY

WING (RIGHT)

ANTENNAE

BELLY

LEGS

KEY

- Opaque black size 11 seed beads
- Silver-lined brown size 11 seed beads
- Opaque black size 8 seed beads
- Opaque black 6-mm bugle beads
- Opaque black 3-mm bugle beads
- Opaque white size 11 seed beads
- Silver-lined orange size 11 seed beads
- ›‹ Attach legs
- | Reduce

ROSY MAPLE MOTH
Dryocampa rubicunda

HABITAT *North America* **WINGSPAN** *1¼ to 2 inches (32 to 51 mm)*

A light combination of gold and pink makes this a perfect summery beading project.

YOU WILL NEED

6½ yd / 5.9 m of 32-gauge / 0.2 mm wire

443 silver-lined dark yellow size 11 seed beads (approx. 4.5 g)

2 pink-lined crystal size 8 seed beads

20 rainbow gold 6-mm bugle beads

306 ceylon pink size 11 seed beads (approx. 3 g)

8 opaque black size 11 seed beads

6 gold red luster 3-mm bugle beads

Wire cutters

Flat-nose pliers

Bradawl

KEY

- Silver-lined dark yellow size 11 seed beads
- Pink-lined crystal size 8 seed beads
- Rainbow gold 6-mm bugle beads
- Ceylon pink size 11 seed beads
- Opaque black size 11 seed beads
- Gold red luster 3-mm bugle beads
- >< Attach legs
- | Reduce

TOP OF BODY

WING (RIGHT)

SIDE OF BODY

BELLY

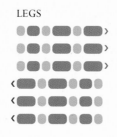

LEGS

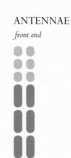

ANTENNAE
front end

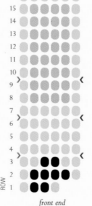

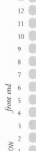

BROWN SPOTTED MOTH
Comostola laesaria

HABITAT *Asia; Australia* **WINGSPAN** ¾ *inches (20 mm)*

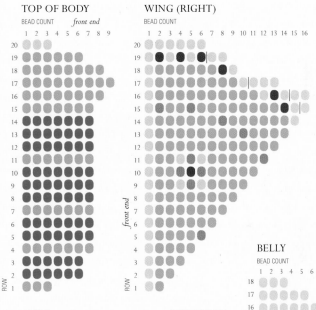

Blue and cream wings alongside a neatly striped green and turquoise body give this insect a chic look.

YOU WILL NEED

*6½ yd / 5.9 m of
32-gauge / 0.2 mm wire*

*367 opaque turquoise size 11
seed beads (approx. 3.75 g)*

2 silver-lined red size 8 seed beads

*224 opaque cream size 11 seed beads
(approx. 2.25 g)*

*128 green-lined clear size 11
seed beads (approx 1.25 g)*

20 opaque cream 6-mm bugle beads

*20 translucent light brown size 11
seed beads*

*14 matte iris dark brown size 11
seed beads*

6 opaque cream 3-mm bugle beads

Wire cutters

Flat-nose pliers

Bradawl

KEY

- Opaque turquoise size 11 seed beads
- Silver-lined red size 8 seed beads
- Opaque cream size 11 seed beads
- Green-lined clear size 11 seed beads
- Opaque cream 6-mm bugle beads
- Translucent light brown size 11 seed beads
- Matte iris dark brown size 11 seed beads
- Opaque cream 3-mm bugle beads
- >< Attach legs
- | Reduce

TOP OF BODY

WING (RIGHT)

SIDE OF BODY

BELLY

LEGS

*** ANTENNAE**
front end

* *The Brown Spotted Moth has shorter antennae than
the basic moth. When you get to step 6, thread only one
seed bead rather than three onto each wire.*

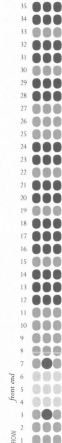

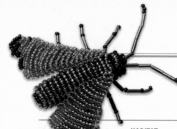

CINNABAR MOTH
Tyria jacobaeae

HABITAT *Asia; Australia; Europe; New Zealand; North America* **WINGSPAN** *1¼ to 1⅝ inches (32 to 42 mm)*

YOU WILL NEED

*6½ yd / 5.9 m of
32-gauge / 0.2 mm wire*

*212 opaque black size 11 seed beads
(approx. 2 g)*

2 opaque black size 8 seed beads

*419 green luster size 11 seed beads
(approx. 4.25 g)*

20 metallic black 6-mm bugle beads

*126 silver-lined red size 11 seed beads
(approx. 1.25 g)*

6 metallic black 3-mm bugle beads

Wire cutters

Flat-nose pliers

Bradawl

This project has a sophisticated color scheme, with lustrous gray and brilliant red wings.

TOP OF BODY

WING (RIGHT)

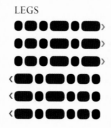

SIDE OF BODY

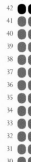
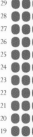

BELLY

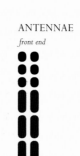

KEY

● *Opaque black size 11 seed beads*
● *Opaque black size 8 seed beads*
● *Green luster size 11 seed beads*
▬ *Metallic black 6-mm bugle beads*
● *Silver-lined red size 11 seed beads*
▬ *Metallic black 3-mm bugle beads*
>< *Attach legs*
| *Reduce*

LEGS

ANTENNAE
front end

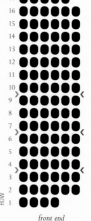

DEATH'S-HEAD HAWKMOTH
Acherontia lachesis

HABITAT *Asia* **WINGSPAN** *4 1/3 to 5 1/4 inches (110 to 132 mm)*

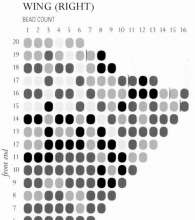

It's the body with its noticeable skull pattern that catches the attention with this hawkmoth.

YOU WILL NEED

*6 1/2 yd / 5.9 m of
32-gauge / 0.2 mm wire*

*249 transparent brown size 11
seed beads (approx. 2.5 g)*

*277 opaque brown size 11 seed beads
(approx. 2.75 g)*

2 opaque black size 8 seed beads

*121 ceylon cream size 11 seed beads
(approx. 1.25 g)*

20 rainbow gold 6-mm bugle beads

*110 silver-lined light brown size 11
seed beads (approx. 1 g)*

6 gold red luster 3-mm bugle beads

Wire cutters

Flat-nose pliers

Bradawl

KEY

- Transparent brown size 11 seed beads
- Opaque brown size 11 seed beads
- Opaque black size 8 seed beads
- Ceylon cream size 11 seed beads
- Rainbow gold 6-mm bugle beads
- Silver-lined light brown size 11 seed beads
- Gold red luster 3-mm bugle beads
- ✕ Attach legs
- | Reduce

TOP OF BODY

WING (RIGHT)

SIDE OF BODY

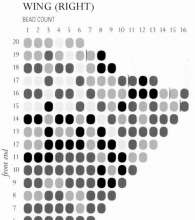

LEGS

ANTENNAE
front end

BELLY

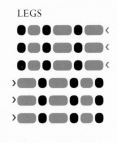

front end

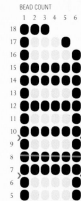

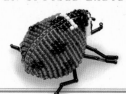

SEVEN-SPOTTED LADYBUG
Coccinella septempunctata

HABITAT *Asia; Europe; North America* **LENGTH** *¹/₄ to ³/₈ inch (8 to 10 mm)*

This relatively challenging project calls on a variety of techniques to create one of the undisputed stars of the bug world, the ladybug. It may take a little practice to get an ideally neat result, but the finished options are so cute that it's worth taking a bit of extra time to get this insect absolutely right. It makes an ideal desk ornament.

MAKING THE HEAD

1 Cut a 31-inch/80-cm length of wire. Following the Front of Head chart on page 66, bead rows 1 through 11. Weave back through the last two rows, trim, and bend the wires to finish.

2 Cut a 31-inch/80-cm length of wire. Thread eight black seed beads onto it. Refer to the Top of Head chart on page 66 to see how these beads (row A) join rows 1 and 11. Thread the wire ends through rows 1 and 11, making sure you go through the correct side as shown. Thread the wires back through rows 2 and 10 and pull tight.

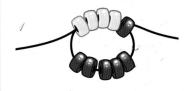

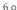

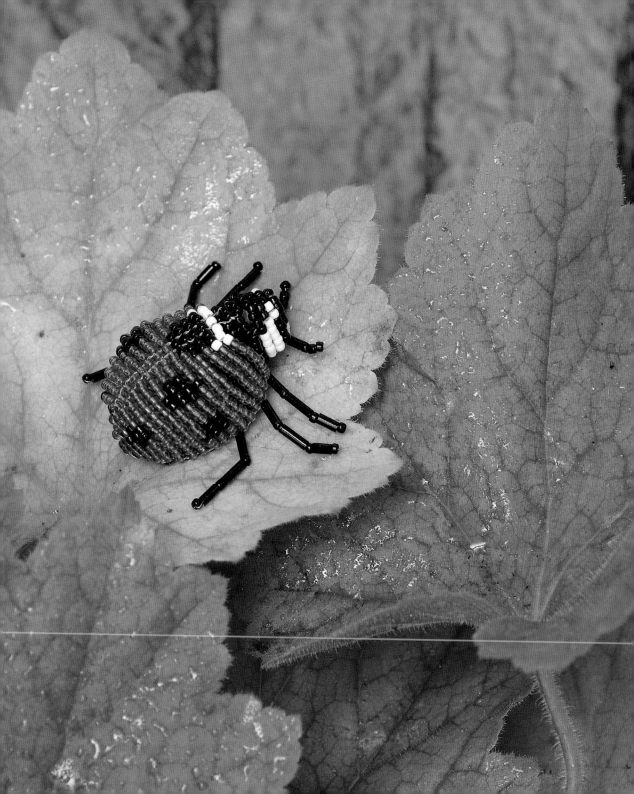

3 For row B, thread eight black seed beads onto the right wire and thread this into row 2. Pass the left wire through these beads and into row 10. Pull tight.

4 Continue weaving through the work to add rows C and D; your wires will then be exiting rows 4 and 8.

5 Following the Feelers chart on page 66, thread one black bugle and three black seed beads onto each wire. Skip the last bead and pass back through the other three beads and into rows 5 and 7. Use the bradawl to tighten.

6 Make a row of two black seed beads to fill the gap at the top of the head. Pass both wires back through rows 5 and 7.

7 Thread both wires up row 6. Thread one wire inside the head. Thread the second wire over and between the last two seed beads and inside the head. Twist together on the inside. Trim both wires to ¼ inch/5 mm.

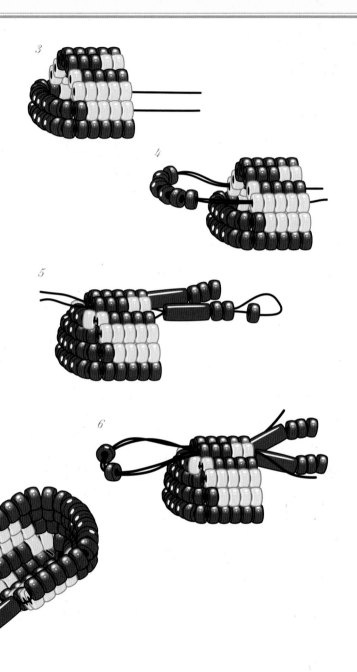

ADDING THE ELYTRA

8 Cut a 35-inch/90-cm length of wire. Holding the head facing toward you, thread the wire into row 1 and the first three beads of row A (the three closest to the right edge). Center the wire and, following the Elytron chart on page 66, begin beading the left elytron. When all rows are completed, secure the wires and trim.

9 Mirror repeat Step 9 to bead the right elytron.

10 Use your fingers to bend and curve the elytra into a round shape so that the head and elytra will lay flat on a table.

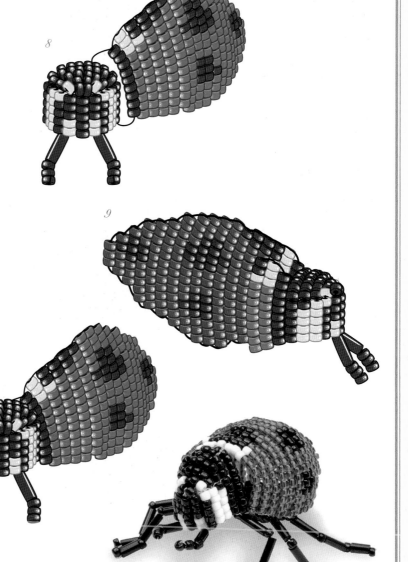

8

9

10

LACING THE ELYTRA

11 You will now use seed beads to join the two elytra. Cut a 16-inch/40-cm length of wire. Center it through the two beads at the back of the head that don't have elytra attached.

12 Thread two black seed beads onto the right wire and thread the left wire through this new row. Hook the right wire behind the loop between rows 1 and 2 of the right elytron. Mirror the hooking on the left side.

13 Add one black seed bead to the right wire; thread the left wire through in the opposite direction. Hook each wire around the next loop on the elytron on the appropriate side.

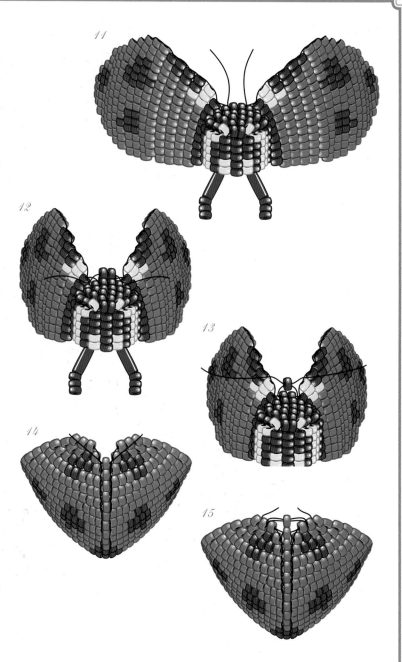

11

12

13

14

15

14 Continue lacing, using first one white seed bead, then four black seed beads, and finally 10 red seed beads, threading and hooking the wires as you did in Step 13 after you add each bead.

15 To finish lacing, add two more rows of one red seed bead and then one row of two red seed beads. Since there are no loops left to attach to, pass through, one at a time, the three beads in row 17 of the elytron. Weave the wire into the work to secure and trim.

MAKING THE BELLY

16 Cut a 35-inch/90-cm length of wire and thread five black seed beads onto it. Turn the ladybug over and thread each end of the wire behind the loops between rows 3 and 4 and 8 and 9 on the head.

17 Following the Belly chart on page 66, bead rows 2 through 19; before picking up each row, hook the wire under the next loop on the elytra to lace the work together as you go. To add the legs to the ends of rows 5, 8, and 11, thread one black bugle bead and one black seed bead three times onto each wire, then skip the last bead added and pass down through the other five. Continue with the next row as usual.

18 Weave your wires back through two rows to secure, then trim and hide. Finally, use a small modeling tool with a round end or a cotton swab to poke into the body through the hole at the end of the belly. Use the tool and your fingers to straighten the rows and perfect the ladybug's shape.

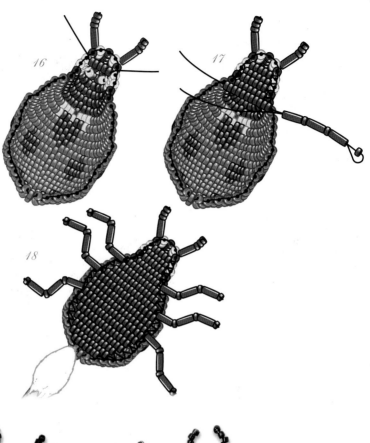

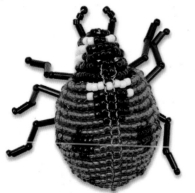

Upper side

Underside

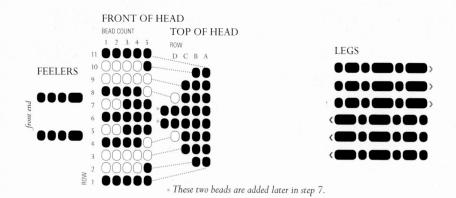

FRONT OF HEAD

BEAD COUNT

TOP OF HEAD

FEELERS

LEGS

These two beads are added later in step 7.

LACING BEADS

ELYTRON (LEFT)

BEAD COUNT

BELLY

BEAD COUNT

front end

front end

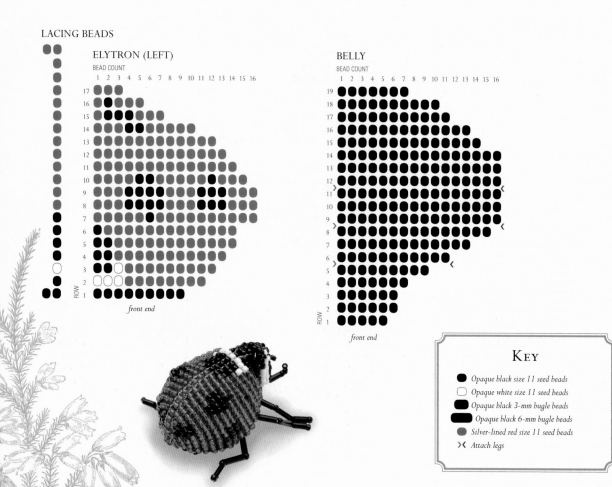

KEY

● Opaque black size 11 seed beads
○ Opaque white size 11 seed beads
● Opaque black 3-mm bugle beads
● Opaque black 6-mm bugle beads
● Silver-lined red size 11 seed beads
〉〈 Attach legs

AUSTRALONEDA LADYBUG
Australoneda burgeoisi

HABITAT *Australia* **LENGTH** *³/₈ inch (10 mm)*

This brown and yellow ladybug, tidily outlined in black, stands out from its spotted brethren, but is equally striking.

You Will Need

5⅛ yd / 4.8 m of
32-gauge / 0.2 mm wire

225 opaque black size 11 seed beads
(approx. 2.25 g)

118 opaque yellow size 11 seed beads
(approx. 1.25 g)

20 metallic bronze 3-mm bugle beads

405 silver-lined brown size 11
seed beads (approx. 4 g)

Wire cutters

Flat-nose pliers

Bradawl

Modeling tool with rounded end
or cotton swab

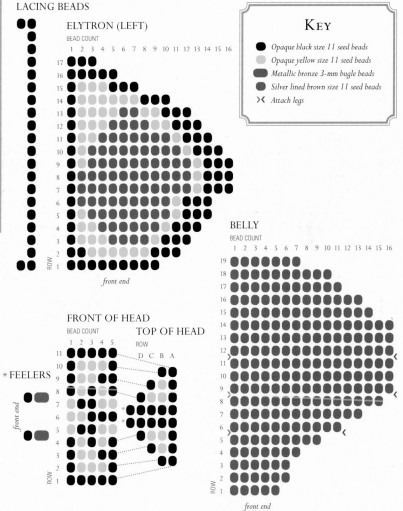

KEY

● Opaque black size 11 seed beads
○ Opaque yellow size 11 seed beads
● Metallic bronze 3-mm bugle beads
● Silver lined brown size 11 seed beads
✕ Attach legs

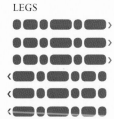

* The Australoneda Ladybug has shorter feelers and legs than the basic moth. When you get to step 5, use only one seed bead for each antenna rather than three. When you reach step 18, use only 3-mm bugle beads rather than a mix of 3-mm and 6-mm bugle beads.

* These two beads are added later in step 7.

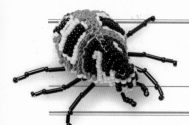

THREE-BANDED LADYBUG
Coccinella trifasciata perplexa

HABITAT *Canada; United States* LENGTH *³/₁₆ inch (4 to 5 mm)*

YOU WILL NEED

5⅛ yd/4.8 m of
32-gauge/0.2 mm wire

396 opaque black size 11 seed beads
(approx. 4 g)

52 ceylon cream size 11 seed beads
(approx. 0.5 g)

6 opaque black 3-mm bugle beads

194 silver-lined orange size 11
seed beads (approx. 2 g)

110 opaque yellow size 11 seed beads
(approx. 1 g)

12 opaque black 6-mm bugle beads

Wire cutters

Flat-nose pliers

Bradawl

Modeling tool with rounded end
or cotton swab

Growing less common in North America, this boldly marked and vivid beetle is still widespread, and is readily identified.

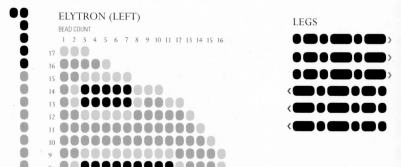

LACING BEADS

ELYTRON (LEFT)

LEGS

BELLY

KEY

● Opaque black size 11 seed beads
○ Ceylon cream size 11 seed beads
▬ Opaque black 3-mm bugle beads
● Silver-lined orange size 11 seed beads
○ Opaque yellow size 11 seed beads
▬ Opaque black 6-mm bugle beads
⟩⟨ Attach legs

FRONT OF HEAD

TOP OF HEAD

FEELERS

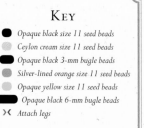

* These two beads are added later in step 7.

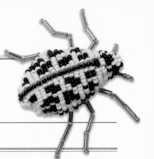

TWENTY-TWO-SPOT LADYBUG
Psyllobora vigintiduopunctata

HABITAT *Europe* **LENGTH** *⅛ to ³⁄₁₆ inches (3 to 4.5 mm)*

Characteristic polka dots—but this European native has them on a pretty yellow ground, which makes for a bright project.

YOU WILL NEED

*5⅛ yd/4.8 m of
32-gauge/0.2 mm wire*

*310 opaque yellow luster size 11
seed beads (approx. 3 g)*

*418 opaque black size 11 seed beads
(approx. 4.25 g)*

8 metallic bronze 3-mm bugle beads

*24 silver-lined brown size 11
seed beads*

*12 silver-lined brown 6-mm
bugle beads*

Wire cutters

Flat-nose pliers

Bradawl

*Modeling tool with rounded
end or cotton swab*

KEY

- Opaque yellow luster size 11 seed beads
- Opaque black size 11 seed beads
- Metallic bronze 3-mm bugle beads
- Silver-lined brown size 11 seed beads
- Silver-lined brown 6-mm bugle beads
- >< Attach legs

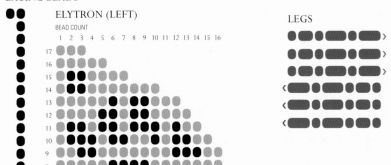

LACING BEADS

ELYTRON (LEFT)

LEGS

front end

BELLY

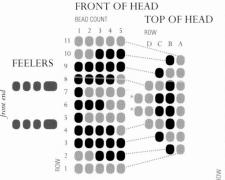

FRONT OF HEAD

TOP OF HEAD

FEELERS

front end

front end

* These two beads are added later in step 7.

STRIPED LOVE BEETLE
Eudicella gralli

HABITAT *Africa* **LENGTH** *1 to 1½ inches (25 to 40 mm)*

A native of central African forests, this gleaming insect is a member of the widespread scarab beetle family. The crossed horn is one feature that marks it out, so we've echoed it in beads, along with silver-lined green beads on the upper body that mimic the brilliance of the original.

YOU WILL NEED

5⅛ yd / 4.8 m of
32-gauge / 0.2 mm wire

205 silver-lined green size 11
seed beads (approx. 2 g)

200 silver-lined brown size 11
seed beads (approx. 2 g)

2 opaque black 3-mm diameter
pearl beads

16 silver-lined brown 6-mm
bugle beads

98 opaque white size 11
seed beads (approx. 1 g)

99 opaque black size 11
seed beads (approx. 1 g)

8 silver-lined dark green size 11
seed beads

Wire cutters

Flat-nose pliers

Bradawl

Modeling tool with rounded
end or cotton swab

MAKING THE BODY

1 Cut a 24-inch/60-cm length of wire. Following the Front of Body chart on page 76, bead rows 1 through 16. Weave, trim, and bend the wire to finish.

2 Cut a 24-inch/60-cm length of wire. Keeping the ends even, wind the wire around the loops between rows 6 and 7 and between rows 10 and 11. Pass the ends through rows 6 and 11.

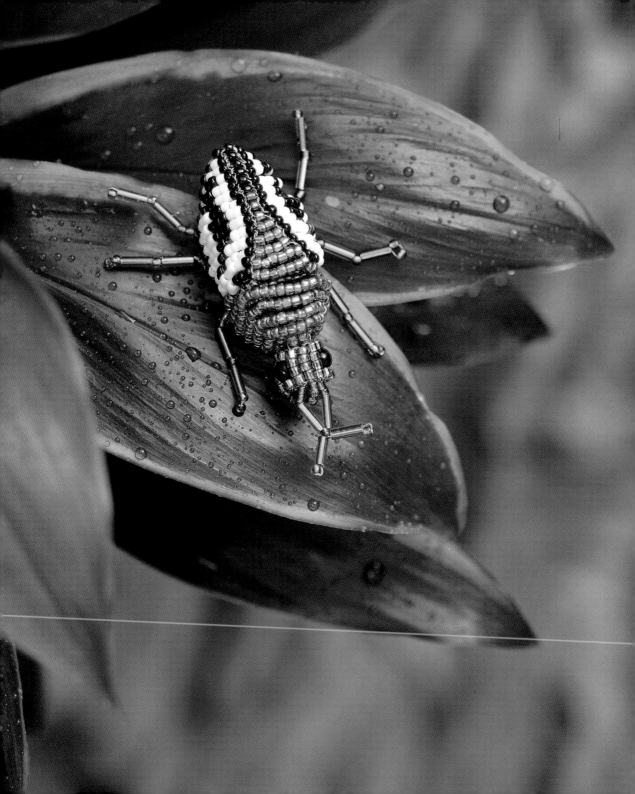

3 Following the Front Top of Body chart on page 76, pick up eight green beads for row A on both wires and pass the wires back through rows 6 and 11. Pull tight

4 Thread the wires through rows 5 and 12. Continue with rows B through E of the Front Top of Body chart, pulling tight after each row so that the Front of Body bends into a U shape. Reduce on row E at the points indicated with red lines on the chart.

5 Continue beading rows F through I, using the basic technique. Leave the wires unfinished for later use.

MAKING THE ELYTRA

6 Cut a 28-inch/70 cm length of wire. With the front of the body facing toward you, thread the wire from right to left through the first row on the right side of the body that doesn't have any of the rows added in steps 3 through 5. Thread two white and three black seed beads. Center the beadwork on the wire and pass the left end of the wire behind the loop between rows E and F.

7 Following the Elytron chart on page 76, bead rows 1 through 5, always winding the left wire around the loops of wires between the rows on the top of the body to lace the two pieces together.

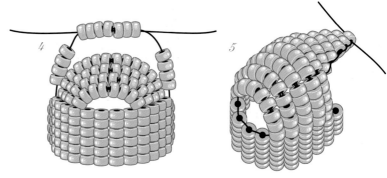

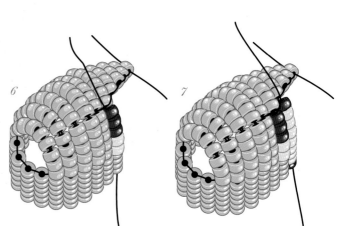

8 Continue beading rows 6 through 14, which aren't laced to the rest of the body. Weave back through the last two rows, trim, and bend your wire to finish.

9 Mirror repeat steps 6 through 8 on the other side.

10 Return to the wires that you left at the end of step 5. Follow the Lacing Beads chart on page 76 to add eight seed beads, one at a time. As you add each row, wind the wires around the loops between rows 5 to 14 of the elytra to lace the them fully together. Bend the elytra to shape the beetle and make sure that it can lie flat on the table.

MAKING THE FACE

11 Cut a 20-inch/50-cm length of wire. Follow the Face chart on page 76 to bead rows 1 through 5.

12 For row 6, pick up one green bead on each wire, then thread each wire through the large black bead and the small bead on the other wire.

13 Continue beading rows 7 through 12, repeating on row 11 what you did on row 6.

14 Thread both wires through row 1 again to turn the strip into a loop.

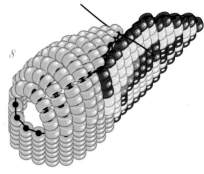

8

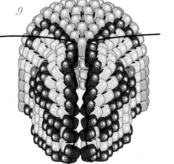

9

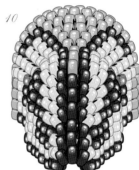

10

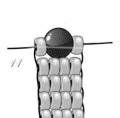

11

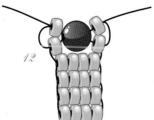

12

13

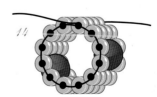

14

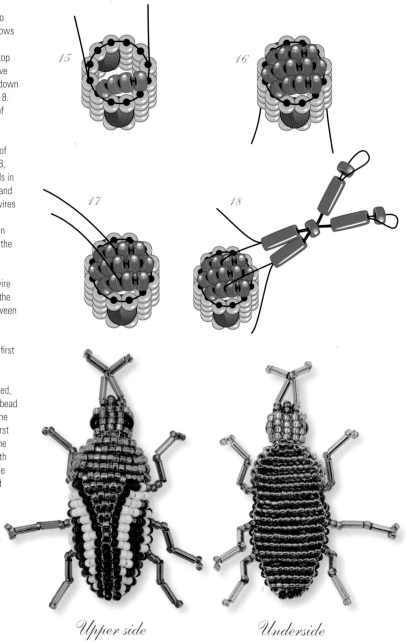

15 Hold the work with rows 7 to 9 to your left and the large bead on rows 10 and 11 toward you. Thread 4 brown beads onto the wire coming out of the top of row 1 (this row of beads will only have one wire through it) and pass the wire down through row 9 and then up through row 8. Pull tight. Thread the wire coming out of the bottom of row 1 up through row 2.

16 Bead rows B and C of the Front of Face chart on page 76. For row B, thread both wires through the five beads in opposite directions, then down rows 2 and 8 and pull tight. For row C, thread the wires back up rows 3 and 7, then through the four beads in opposite directions. When finished, leave the wires coming out of the back of the head for later use.

17 Cut an 8-inch/20-cm length of wire and gently bend it in half. From the inside of the face, thread one wire between rows 7 and 8 and through the first two beads in row C; thread the other wire between rows 8 and 9 and through the first two beads in row A.

18 Thread one bugle, one brown seed, one bugle, and one brown seed bead onto one wire. Thread one bugle onto the other wire, pass the wire through the first seed bead on the first wire, then add one bugle and one brown seed bead. On both wires, skip the end seed beads, pass the wires back through the other beads and into the work through rows A and C where they originally exited, down the other two beads in rows A and C, and through rows 1 and 3. Trim and bend the wires to finish.

Upper side

Underside

19 Return to the wires left at the end of step 16. Holding the top of the head and the body top upward (the top of the head has three rows of green beads between the eyes), pass the lower wire behind the two center-most rows on the front of the body and back through row 3 of the face. Pass the lower wire behind the same two rows at the front of the body and back through row 7 of the face. Pull both tight to make the face sit correctly against the body. Weave, trim, and bend the wires to secure.

MAKING THE BELLY

20 Cut a 35-inch/90-cm length of wire. Thread six brown beads onto the center and pass the ends behind the loops on the body between rows 5 and 6 and between rows 12 and 13. Pass both wires back through the row of beads and hook behind the loops between rows 4 and 5 and between rows 13 and 14.

21 Follow the Belly chart on page 76 to bead rows 2 through 16, continuing to hook behind the loops on the elytron edge to hold the belly to them. When you reach rows 4, 8, and 11, pick up the appropriate beads for each leg and, skipping either two (four front legs) or one (two back legs) seed beads, pass back through all the other leg beads. Continue beading the belly. Weave, trim, and bend the wires to finish.

22 Place a small modeling tool or cotton swab into the body and use the tool and your fingers to shape, straighten, and neaten the body.

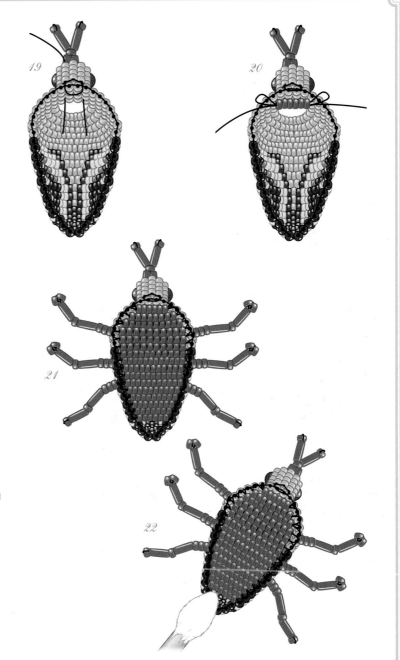

FRONT OF BODY

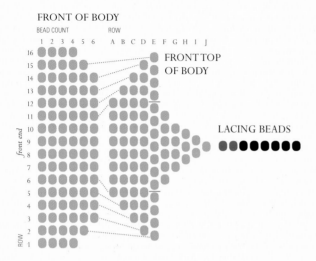

BEAD COUNT ROW

FRONT TOP OF BODY

LACING BEADS

BELLY

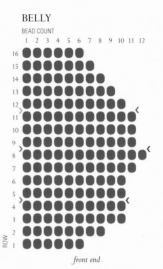

BEAD COUNT

front end

FACE

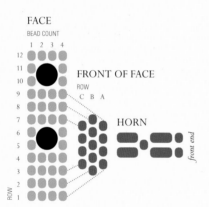

BEAD COUNT

FRONT OF FACE

ROW

HORN

front end

ELYTRON (LEFT)

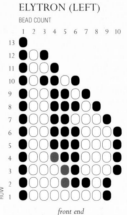

BEAD COUNT

front end

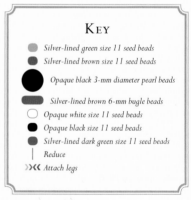

KEY

- Silver-lined green size 11 seed beads
- Silver-lined brown size 11 seed beads
- Opaque black 3-mm diameter pearl beads
- Silver-lined brown 6-mm bugle beads
- Opaque white size 11 seed beads
- Opaque black size 11 seed beads
- Silver-lined dark green size 11 seed beads
- | Reduce
- >|< Attach legs

LEGS

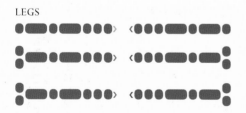

LACING BEADS

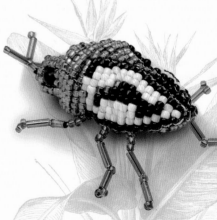

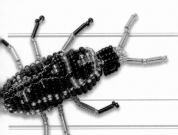

FIDDLER BEETLE
Eupoecila australasiae

HABITAT *Australia* **LENGTH** *⅝ to ¾ inches (15 to 20 mm)*

This vivid Fiddler Beetle is found in Australia, and is so called because of the fiddle-like curves marked on its back.

You Will Need

5⅛ yd / 4.8 m of
32-gauge / 0.2 mm wire

403 opaque black size 11 seed beads
(approx. 4 g)

180 translucent green size 11
seed beads (approx. 1.75 g)

2 opaque black 3-mm diameter
pearl beads

10 silver-lined brown 6-mm
bugle beads

28 silver-lined brown size 11
seed beads

6 opaque black 6-mm bugle beads

Wire cutters

Flat-nose pliers

Bradawl

Modeling tool with rounded end or
cotton swab

Key

● Opaque black size 11 seed beads
● Translucent green size 11 seed beads
● Opaque black 3-mm diameter pearl beads
▬ Silver-lined brown 6-mm bugle beads
● Silver-lined brown size 11 seed beads
▬ Opaque black 6-mm bugle beads
| Reduce
≫✕≪ Attach legs

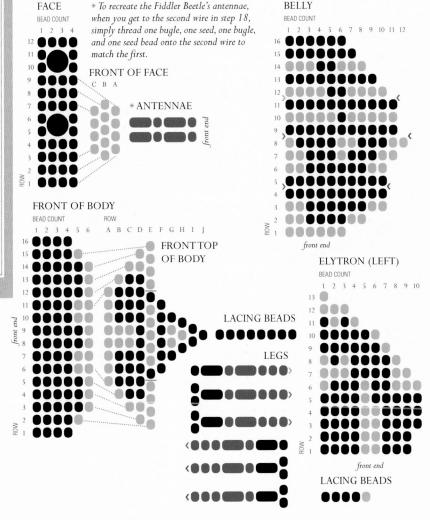

*To recreate the Fiddler Beetle's antennae, when you get to the second wire in step 18, simply thread one bugle, one seed, one bugle, and one seed bead onto the second wire to match the first.

77

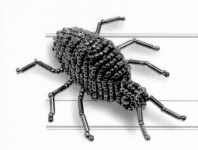

PURPLE JEWEL BEETLE
Smagdethnes africana oertzeni

HABITAT *Africa* **LENGTH** *¾ inches (20 mm)*

This member of the jewel beetle family has gleaming metallic armor, which can be matched with rainbow seed beads.

YOU WILL NEED

*5⅛ yd / 4.8 m of
32-gauge / 0.2 mm wire*

*611 rainbow dark purple size 11
seed beads (approx. 6 g)*

*2 metallic black 3-mm diameter
pearl beads*

*16 rainbow dark purple 6-mm
bugle beads*

Wire cutters

Flat-nose pliers

Bradawl

*Modeling tool with rounded
end or cotton swab*

KEY

● *Rainbow dark purple size 11 seed beads*

● *Metallic black 3-mm diameter pearl beads*

▬ *Rainbow dark purple 6-mm bugle beads*

| *Reduce*

\>\< *Attach legs*

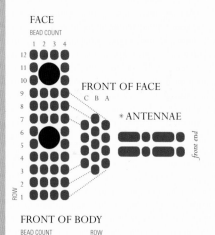

FACE
FRONT OF FACE
* ANTENNAE
FRONT OF BODY
FRONT TOP OF BODY

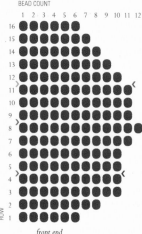

BELLY
ELYTRON (LEFT)

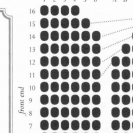

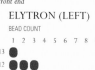

LACING BEADS

LEGS

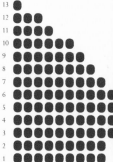

LACING BEADS

** The Purple Jewel Beetle has antennae rather than a horn. When you get to step 18, instead
of threading one bugle bead onto the second wire and passing the wire through the first seed
bead on the first wire and then adding one more bugle bead and seed bead, simply thread
one bugle, one seed, one bugle, and one seed bead onto the second wire to match the first.*

PAPUA NEW GUINEA BLUE BEETLE
Eupholus bennetti

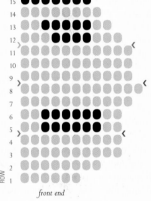

HABITAT *Papua New Guinea* **LENGTH** *1 inch (26 mm)*

Exotically marked, this beetle would look just as good ornamenting a lapel as it does in its native rainforest.

You Will Need

5⅛ yd / 4.8 m of 32-gauge / 0.2 mm wire

431 frosted pale blue size 11 seed beads (approx. 4.25 g)

180 opaque black size 11 seed beads (approx. 1.75 g)

2 opaque black 3-mm diameter pearl beads

16 aurora borealis matte transparent turquoise 6-mm bugle beads

Wire cutters

Flat-nose pliers

Bradawl

Modeling tool with rounded end or cotton swab

Key

- Frosted pale blue size 11 seed beads
- Opaque black size 11 seed beads
- Opaque black 3-mm diameter pearl beads
- Aurora borealis matte transparent turquoise 6-mm bugle beads
- | Reduce
- >|< Attach legs

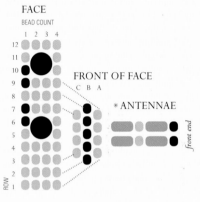

FACE

FRONT OF FACE

* ANTENNAE

BELLY

FRONT OF BODY

FRONT TOP OF BODY

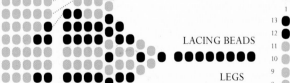

LACING BEADS

LEGS

ELYTRON (LEFT)

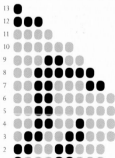

LACING BEADS

* The Blue Beetle has antennae rather than a horn. When you get to step 18, instead of threading one bugle bead onto the second wire and passing the wire through the first seed bead on the first wire and then adding one more bugle bead and seed bead, simply thread one bugle, one seed, one bugle, and one seed bead onto the second wire to match the first.

INDEX

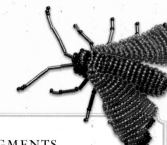

ACKNOWLEDGMENTS

IVY PRESS would like to thank all the people who generously created the bug variations that appear in this book:

Marion Bush *(Fiddler Beetle, p77),* Natalie Cotgrove *(Twenty-Two-Spot Ladybug, p69),* Lynne Faulkner *(Cinnabar Moth, p58),* Tom Lawrence *(Brown Hooded Owlet Moth Caterpillar, p37),* Chris Linacre *(Hoary Skimmer Dragonfly, p46),* Amy Mackin *(Australoneda Ladybug, p67),* Mary Marshall *(Purple Emperor, p22; Banded Demoiselle, p49),* Sue Mead *(Rosy Maple Moth, p56),* Marie New *(Australian Grapevine Moth Caterpillar, p39),* Carol Passaro *(Hobart's Red Glider, p21;*
Alder Moth Caterpillar, p38; Cardinal Meadowhawk, p48), Bernice Perkins *(African Swallowtail, p31; Brown Spotted Moth, p57),* Karen Phillips *(Orange Oakleaf, p23; Malabar Banded Peacock, p29),* Sanya Preston *(Death's-Head Hawkmoth, p59),* Nadine Sharpe *(Black Swallowtail, p30; Papua New Guinea Blue Beetle, p79),* Debbie Skelton *(Four-Spotted Skimmer, p47),* Sue Ticehurst *(Purple Jewel Beetle, p78),* Angela Wallis *(Three-Banded Ladybug, p68).*